Focus on Danish History

Thomas
Bloch Ravn

The Story of Danish Museums

Aarhus University Press

© Thomas Bloch Ravn and
Aarhus University Press 2020
The Story of Danish Museums
Part of the series Focus on Danish History
Original Danish title and series:
Museer for folk, 100 danmarkshistorier
Editor: Peter Bejder
English translation: Heidi Flegal

Design, layout and cover:
Camilla Jørgensen, Trefold
Pre-press: Narayana Press
Printing: Narayana Press
Printed on 130 g Munken Lynx

Printed in Denmark 2020
ISBN: 978 87 7219 170 6

The history project 100 danmarkshistorier (Focus on
Danish History) is supported by the Danish charitable
foundation A.P. Møller og Hustru Chastine Mc-Kinney
Møllers Fond til almene Formaal.

Publication of this English edition is supported by the
Danish charitable foundations Bodil og Jørgen Munch-
Christensens Kulturlegat, and Fabrikant Albert Nielsens
og Hustru Anna Nielsens Fond.

The Danish history project's steering group consists
of Thomas Bloch Ravn (Den Gamle By), Thorsten
Borring Olesen (Aarhus University), Mette Frisk Jensen
(danmarkshistorien.dk), Søren Hein Rasmussen (Meg-
aNørd), Torben Kjersgaard Nielsen (Aalborg Universi-
ty), Bo Lidegaard (historian and author), Anne Løkke
(University of Copenhagen), Camilla Mordhorst (Danish
Cultural Institute), Lars Boje Mortensen (University of
Southern Denmark), Keld Møller Hansen (Danish Castle
Centre), Rikke Louise Alberg Peters (National Centre of
Excellence for the Dissemination of History and Cul-
tural Heritage), Hans Schultz Hansen (Danish National
Archives), Nils Arne Sørensen (University of Southern
Denmark), Sten Tiedemann (Danish University Exten-
sion in Aarhus), Ulla Tofte (M/S Maritime Museum of
Denmark) and Anette Warring (Roskilde University).

This series is supported by multimodal content, mainly
in Danish. Visit 100danmarkshistorier.dk to learn more.

Aarhus University Press
Finlandsgade 29
8200 Aarhus N
Denmark
www.unipress.dk

**PEER
REVIEWED**

/ In accordance with requirements of the Danish Ministry of Higher Education and Science, the certification
means that a PhD level peer has made a written assessment justifying this book's scientific quality.

MIX
Paper
FSC FSC® C010651

Contents

The battle of the museums

Prehistory

Müller's model

Modern times

Museums about people

The future

The Mayor's House, at the National Exhibition held in Aarhus in 1909. Its presence there was the outcome of a clash between two museum factions with very different views. This has since coloured the Danish discourse on the role of museums in society. Should they mainly focus on objects, or on people? Section of a drawing by Franz Šedivý (1864–1945). || *Illustreret FamilieJournal*/Royal Danish Library

The battle of the museums

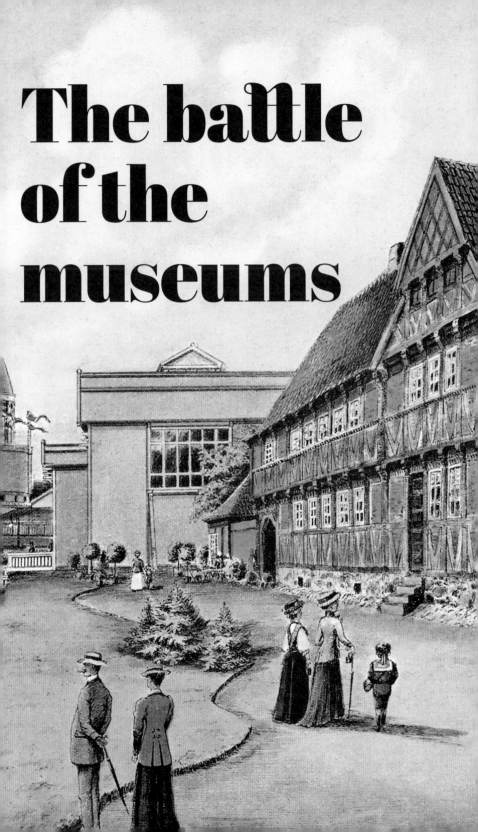

From pre-history to people

The Danish National Exhibition of 1909 was held in Aarhus. This was a huge event for the town, marking its new rank as the country's second-largest urban centre – though not yet a true city. Opening on Tuesday, 18 May 1909, it showcased Denmark's best industrial products, craftsmanship and culture. One young teacher from Aarhus was particularly pleased and excited that day. His name was Peter Holm (1873–1950), and it was thanks to his enormous efforts that a historical exhibition was to be shown in a building newly named the 'Old Mayor's House' – erstwhile home to several town mayors – which had been relocated to the exhibition grounds and re-erected there, piece by piece. It was a make-or-break moment. The guests would include the King, the Crown Prince, the town's Lord Mayor and a host of other public figures.

Peter Holm was immensely proud. He was also on the verge of collapse, having worked day and night to get the Old Mayor's House and its period rooms ready for the grand opening – the culmination of his pet project and passion since 1907.

It had not been easy. While the exhibition's organisers had consistently supported Holm's work

and vision, a certain circle behind Aarhus Museum (founded in 1861) had fought the entire project. Little wonder that when the National Exhibition closed almost six months later, Holm was relieved to find that the Old Mayor's House had been among its most successful attractions.

This fuelled Holm's keen historical interest. His dream of a permanent open-air museum for urban cultural history began to take shape, with the Old Mayor's House as its beating heart. His ambition was to found a museum about the people who had lived out their lives in the Danish merchant towns. He envisioned a museum not just for those who shared his special interest, but for all those whose hearts and minds such a place could reach. His dream became a reality. Five years later, in 1914, Holm opened the doors to a museum which, in just a few years, had developed into Den Gamle By – 'the old town'.

Peter Holm's thinking and plans squarely contradicted the mainstream view in museum circles: that scientific pursuits and prehistory – the time before written sources – were a museum's highest purpose. The irreconcilable conflicts to which this gave rise are the backdrop of the story in this book. Some might say the controversy was only interesting or remarkable for Aarhus, or for Denmark. Initially it was provincial, even parochial I admit, yet its perspectives are wider. In fact, the conflict described here is a clearly manifested articulation of various clashes that occurred within the museum communities of Denmark and certain other countries. In Denmark these disputes solidified in the decades around 1900, becoming embedded in the mindsets and in the structures and dilemmas that have since typified the Danish museum landscape. Should museums be about *objects*, or about *people*?

Is distant prehistory more important than the times visitors can relate to personally? Should museums be for researchers or for ordinary people? And who should decide what museums ought to be?

In that sense the battle over the Mayor's House mirrors the broader history of Denmark's cultural-history museums. Note that we are not talking about museums of art or natural history. Rather, our main concern here is the history of museums that deal with cultural history, harking back to royal and aristocratic cabinets of curiosities – represented most prominently in Denmark by the Royal Cabinet of Curiosities, assembled in Copenhagen in the mid-1600s from even older collections. These cabinets eventually evolved into today's rich and varied museum community, as seen in Denmark's gradual move towards more inclusive museums that reach out to a wider audience.

This broad appeal is one reason why Danish museums are attracting more and more guests: in 2018, over eight million individual admissions to cultural-history museums alone – in a country of 5.8 million. In Denmark, cultural-history museums are a crucial window for personal identity and history. This trend may also suggest a greater need for contemplation nowadays. Taking a moment to wonder: Where did we come from, and where are we going? As is often said of the present, 'now' is just the blink of an eye. A place we perch, briefly, on the way from past to future. History is what ties it all together, and that is where the credibility of museums, and their popular base, have a vital role to play.

The eyes of a stranger
The rootedness of Danish and other Scandinavian museums in ordinary people's lives was underscored by the Catalan journalist Lara Saiz Moya

during a visit to Den Gamle By open-air museum one fine spring day in 2014. Moya had spent a few months in Aarhus and visited Den Gamle By several times, and that day we discussed its history. With Aarhus as her base, she had seen cultural museums in Denmark, Sweden and Norway, noting their focus on people as a unique trait.

The eyes of a stranger often discern more acutely the things locals take for granted. So too the Catalan journalist in Scandinavia. While the museums Moya had seen elsewhere especially focus on what is exceptional – superb art, ancient objects, great memorials, castles, citadels, churches and extraordinary objects, describing the history and power of the elite – in Scandinavia she saw museums that focus on ordinary lives and history. Not just in olden times, but (nearly) up to the present. She also noticed how our museums are often more inviting and communicative towards a more diverse audience.

This focus can be traced back to the ideal philosophy of Enlightenment, which in the late 1700s aimed to educate and edify the population at large. Also, part of the National Romanticism of the 1800s was the need to create common, cohesive identities for the emerging nation-states of Europe. Finally, the decades around 1900 saw a wide range of fundamental shifts occur in the complex process that created the Danes as a people and gave them democratic rights, equality and a sense of citizenship in the emerging modern society. This shift strongly affected the Danish language, and Norwegian and Swedish, adding loads of compound words with the prefix *folke-*: 'of the people', or 'popular' in the sense 'broadly rooted'. Notable examples include *folkestyre* (democracy), the *Folketing* (the Danish parliament), *folkeskole* (the public school system), *folkehøjskole* (a folk high school) and *folkekirken*

Peter Holm was 26 years younger than Aarhus Museum's board chairman, Consul Frederik Ollendorff (1847–1918) – a gap that matched the gulf between their views of what a museum ought to be. Ollendorff found it crucial to show prehistory through individual objects, while Peter Holm wanted to show lives and stories from the recent past. Photos taken around 1910.
|| Den Gamle By

(the Danish Lutheran state church). And, of course, the Scandinavian *folkemuseer* (folk museums).

The Welsh museum director John Williams-Davies (b. 1949) pointed out in an article from 2009 in the British journal *Folk Life*, that the Scandinavian open-air museums founded around 1900 were quite unique. First, they concentrated on showing the history *of* ordinary people – as the first ever, he emphasised. Second, their ambition was to present history *for* ordinary people. Not just an exceptional approach, but radically new.

This special Scandinavian inclination is little more than a century old. And looking back at the turbulent times when museum visions and concepts struggled for dominance, it was by no means certain this inclination would prevail, or gain such a strong following as to become a trait that strangers to the region notice. This point is plainly illustrated in the story of the stormy and ultimately irreconcilable conflict in the formative years of Den Gamle By, from 1907 to 1914.

The dispute

The figure at the core of the conflict was Peter Holm, born on 14 May 1873 into a family of craftsmen in Aarhus. He graduated as a teacher in 1891, and in 1898 he also became a certified translator. He never earned an academic degree, but even as a youth Peter Holm was fascinated by his home town and its history, and concerned about the inexorable changes progress brought to the streets, squares and urban quarters he knew so well and could recall in minute detail. An avid traveller, he had visited numerous museums abroad, and his hard-working, practical, solution-driven approach made him much sought after in his home town.

In 1907 he was elected to the board of Aarhus Museum and became involved in the exhibition plans for 1909. These two functions were to become intimately linked in Holm's life, affecting it in very different ways.

Aarhus Museum, founded in 1861, was one of the first Danish museums outside Copenhagen. Focusing on prehistory, it paid little heed to the modern history of recent centuries, or to people's daily lives back then. The secondary collection of more recent objects became Holm's remit when he joined the board in 1907.

The National Exhibition also called on the young teacher, asking him to organise its historical contents. Like the great world's fairs (beginning in London in 1851), the 1909 National Exhibition in Denmark aspired to not only look to the future, but to combine this with looking into the past.

Seeking a physical framework for his exhibition, Holm heard of a large merchant complex from 1597 in the heart of Aarhus, half-timbered in the Renaissance style. The complex was slated for demolition and had recently been sold to a master carpenter

who could get the job done. Several previous owners had been lord mayors of Aarhus, so Peter Holm dubbed it 'the Old Mayor's House' and hatched a plan: He would move the whole thing to the exhibition and fill it with objects and interiors that would display the history of Aarhus and its townsfolk back to the Renaissance, around 1600.

Even this early stage held the embryonic idea of an effort which, over time, would grow into the open-air old-town museum, Den Gamle By. In January 1908 the board of Aarhus Museum approved a grant of 1,000 Danish kroner to purchase the old complex, on the condition that it become the property of the museum when the event closed. When the National Exhibition Committee granted an equal sum, the purchase was a done deal.

At this time, the Aarhus Museum board was split into two camps over the issue of museum policy. The basic conflict was whether it was professionally and historically acceptable to move the old complex and use it to house the history section of the National Exhibition. The conservative camp led by a prominent merchant, Consul Frederik Ollendorff (1847–1918) – the board's chairman – rallied under words like "imitation" and "damned rubbish". In this Ollendorff echoed his idol on museum policy, the scientist and archaeologist Sophus Müller (1846–1934), who was director of the 'first section' at the National Museum in Copenhagen and insisted on the supremacy of Denmark's capital-city museums, on the primacy of prehistory, and on science as the highest purpose of every museum.

In the other camp, Peter Holm was supported by a well-known architect, Hack Kampmann (1856–1920), who in 1892 had been appointed as royal building inspector stationed in Aarhus. He was also on the museum's board from 1896 until

he left Aarhus in 1908. Another firm supporter was Holm's close friend Christian Axel Jensen (1878–1952), who was an expert on timber-framed buildings and worked in the 'second section' at the National Museum. The extensive correspondence between Holm and Jensen contains Holm's own candid account of the skirmishes with the board's conservative wing. In a letter dated 29 September 1908, Holm wrote of "a stormy board meeting" at Aarhus Museum, the topic of which, yet again, was the Mayor's House. Consul Ollendorff reportedly declared that under no circumstances were Holm and his cohorts to imagine they might take over the complex if it became part of the exhibition.

"No, we would have to chop it up for tinderwood, to gain as much as possible from the 1,000 kroner we would have been foolish enough to sink into it."

This is how Holm quoted the chairman, adding that Ollendorff underlined his position by pointing out that "Sophus Müller would not have approved of such tomfoolery".

This spurred architect Kampmann to action and, according to Peter Holm, he gave as good as he got:

"Ollendorff, you are a fossilised old fogey. Indeed, sir, you are! We have here the most momentous matter this museum has ever dealt with since its inception, and yet you cannot make do with shamefully holding your tongue, as these are matters quite beyond your grasp. No, you actually attempt to trip up those who would make a real effort for the museum. Fie upon you, sir! You ought to be ashamed of yourself."

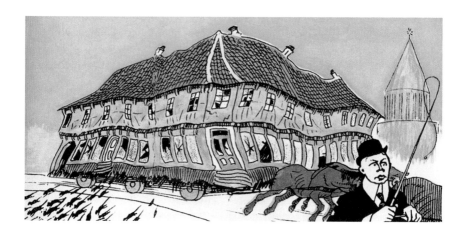

In Holm's rendition, Ollendorff retorted, "So you say, but I was damned well leaving anyway!" Then came Kampmann's repartee:

"Oh yes, do take your leave. You are the worst of the worst [...]. Now keep your nose out of things that are beyond your comprehension. And what is more, do not hurt he who comes in good will, to do good work."

Back then, conservative museum circles often used "rubbish" and "imitation" when reproaching those who worked with the culture of ordinary folk, not least the new open-air museums, which they did not even regard as museums. This camp had three main issues. First, the period and material of such museums – modern history – was much too recent to be interesting. A merchant complex from 1597, for instance, was not nearly old enough for those used to poring over relics of ancient cultures. Second, a plan like Peter Holm's, which would re-create a building that was several centuries old, was "imitation": mouldering timber and crumbling bricks would have to be replaced and original wall decorations and other details restored. Ollen-

dorff – and Müller – did not care one whit that the reconstruction would be done after archaeological scrutiny of the structure, nor did it matter that the deteriorated elements would be replaced by materials of precisely the same type, age and crafting. Third, the conservative camp was against removing or relocating a building or ancient monument from its original site.

Meanwhile, the timber-frame experts from the National Museum, who were not part of Sophus Müllers first section, held a very different view. In fact, prior to the heated discussions in the board room at Aarhus Museum, a team headed by Christian Axel Jensen had methodically studied the old building, concluding that the Mayor's House was

"the only major complex from the days of King Christian IV [1588–1648] to be preserved in its previous entirety, and it is, in all things, one of our most notable half-timbered houses; perhaps the most notable of its time. Also, the house is of quite particular interest, as it is the oldest preserved merchant-town structure in Denmark to be furnished with suspended galleries, which later, during the seventeenth to eighteenth centuries, became so common in our towns."

On 12 May 1908, the organisation behind the upcoming National Exhibition granted the 25,000 kroner it would presumably cost to relocate and rebuild the Mayor's House and furnish it with exhibits. That September the complex was taken down, further studied and documented, moved and re-erected, then outfitted with historical interiors – bringing us full circle to where we began, with the opening itself.

The National Exhibition

Placing the grand National Exhibition in Aarhus was a signal: This was not just any provincial town. In 1909, Aarhus was the largest urban centre on the Danish mainland, its population of 60,000 having grown from 4,000 in a century. During the 1800s, Aarhus laid the groundwork for remarkable growth. The port was expanded several times after Aarhus became a hub on the rail network, from 1862 on, attracting many energetic innovators. This growth in quantity was paralleled by a qualitative surge in the town's self-awareness, reflected in the National Exhibition – an event so large and prestigious that many Aarhusians (and other Danes) still refer to it today as a 'world's fair'.

When the idea was first tabled, some could not imagine a national exhibition outside Copenhagen. Among the sceptical voices was the respected newspaper *Politiken*, which in 1906 found it ill-fated to stage such an event "in the provinces". A desperate venture, since a town so small could hardly lift a task as momentous as a *national* exhibition. Surely, a *Jutland* exhibition would suffice? The newspaper's predictions were soon put to shame. The exposition looked increasingly like a success in the making, so *Politiken* changed its tune, eventually building its own pavilion on the grounds and publishing a special-edition newspaper for the duration.

The National Exhibition aimed to showcase the best Denmark had to offer in the new, modern age. The architect Anton Rosen (1859–1928) was head supervisor, and he created a distinct totality of structures uniformly done in simple, white-painted wood, but each reflecting its own historical style. This earned the exhibition its Danish name, *Den Hvide By*, 'the white city' – coincidentally echoing a popular name for the 1893 world exposition in

Chicago. And the Aarhus event really was big, for Denmark and for its day. Enormous exhibition halls, an electricity tower, restaurants, columns, triumphal arches and pavilions galore. Only one building from the White City in Aarhus has survived: the pavilion Rosen designed for *Politiken*, which was moved to Den Gamle By for the 2009 centennial. The structure is noteworthy in itself, but seeing it in contemporary photos and maps dwarfed by adjacent buildings shows just how huge the 1909 exhibition was.

Besides the exhibits for trade and industry and Peter Holm's historical exhibits, there was an art exhibition, an entire idealised railway town, a public library, a dairy exhibition and operating workshops. The grounds lay along the bay, south of Aarhus proper, so there was also a quay where a historic frigate lay docked. After getting their fill of practical and edifying displays, visitors could find rest and recreation in the People's Park section. The Danish author and Nobel laureate Johannes V. Jensen (1873–1950) visited the park and afterwards described its "various diversions such as a dance estrade, a water and air castle, an area for balloon launches, an Abyssinian encampment and other good fun!"

The National Exhibition in Aarhus, open from May to October 1909, had 667,000 visitors, some ten times the town's population. The weather was not clement – and although Danish summers are notoriously fickle, this one was exceptionally wet and disappointing. And despite its value to posterity in marking Aarhus as second only to Copenhagen, the event as a whole left behind a financial crater. Not so for the Old Mayor's House, though. Thanks to the entrance fee of 25 øre for each of its 100,000

visitors, it brought in precisely the 25,000 kroner it had cost to knock down, move, rebuild and furnish.

With its colourful Renaissance half-timbering the Mayor's House was quite striking amid the White City's pristine façades, and like the fair itself, it looked ahead *and* back in time. While its own age and contents made it a historical display, the mode of exhibition was brand-new and most unlike Aarhus Museum. The building contained a cavalcade of authentically furnished period rooms dating from 1600 onwards, so visitors could stroll past a progression of interiors from the Renaissance, Baroque, Rococo, Empire and Biedermeier periods. The last room recreated 1848, the time of many visitors' own parents and grandparents, forging a direct link between displayed history and visitor – a first for a Danish museum exhibition.

The Mayor's House and its contents put contemporary Aarhus in a historical context and showed the great progress from 1600 to 1909. The whole exposition's faith in a bright future, already convincingly demonstrated, was confirmed and thrown into relief.

One room contained banners, chests, staffs and other ceremonial objects from the old trade guilds, whose influence in Denmark had been curbed about fifty years earlier with the Freedom of Trades Act of 1857, paving the way for competition and industrial thinking. And occupational freedom brought industrialisation, eliminating many old-style workshops where a master craftsman would work with his journeymen and apprentices. Craftsmen became skilled labourers. Many older exhibition visitors had been through this transition, which was still changing society in 1909.

The Danish journal *Architekten* asked Christian Axel Jensen of the National Museum for a contri-

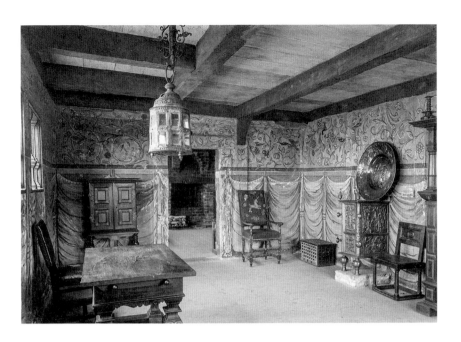

bution, and two August issues ran his thorough description of the Mayor's House as a building and an exhibition. He described it as

"The first complete series of upper-middle-class museum interiors in this country; an exhibition the Copenhagen collections, despite all their treasures, cannot match."

Jensen also addressed the 'imitation' critique. Conceding it might be fair to question certain details, he maintained that the project had been able "to restore the house to its original appearance [...] creating a building that appears surprisingly genuine." Jensen ended by humbly wishing it would be possible to "save it from the destruction that looms when the Aarhus exhibition closes." Jensen, who was Denmark's leading timber-frame expert, ended with a direct reference to Consul Ollendorff's

callous statements, rhetorically asking: "Would it not be too barbaric to chop it up for tinderwood?"

His wish was granted, and ironically the anachronistic building that snuck into the 1909 National Exhibition was one of the few structures to survive.

A Scandinavian idea

There is little doubt that right from the start, Peter Holm and Christian Axel Jensen hoped to build the kind of new folk and open-air museum emerging elsewhere in Scandinavia and, notably after World War II, elsewhere in the world. Gradually most European countries, though not in the Mediterranean region, established open-air museums, a format also found today in the United States, Canada, Australia and Japan.

Sweden was first off the mark when a double museum opened in Stockholm, making their founder, a teacher named Artur Hazelius (1833–1901), the originator of the world's first folk museum, Nordiska Museet ('the Nordic museum, in 1873) *and* the world's first open-air museum, Skansen (in 1891). In 1892, just a year after Skansen opened, Georg Karlin (1859–1939) opened Sweden's second folk and open-air museum, Kulturen ('the culture'), in Lund. Four years later, in 1896, the librarian Hans Aall (1869–1946) opened Norsk Folkemuseum ('the Norwegian folk museum) near Oslo, followed i 1904 by the opening in Lillehammer of Maihaugen by the dentist Anders Sandvik (1862–1950). Meanwhile, in Denmark the art director at Tivoli Gardens, Bernhard Olsen (1836–1922), had opened Dansk Folkemuseum ('the Danish Folk Museum') in 1885, joined in 1901 by Frilandsmuseet ('the Open-Air Museum') in Lyngby north of Copenhagen.

The year 1914 saw the opening of the three Aarhus buildings which, over time, grew into Den Gamle By: the Mayor's House, a Renaissance house, and a small summerhouse. Peter Holm set them along a curved street, making the museum seem so much like a home-grown merchant town that many people still think Den Gamle By is an original 'old town' district of Aarhus. Photo taken around 1914.
|| Den Gamle By

Many of the new museums combined the role of the folk museum and the open-air museum. Unlike older museums, they focused on the daily lives and practices of ordinary people and mainly dealt with modern history. The folk museums contained everyday objects displayed as interiors. The open-air museums went one step further, re-creating interiors in historical buildings embedded in landscapes that resembled their original surroundings. Many open-air museums featured staff in traditional clothing and demonstrations of crafts and handiwork. Since the mid-1900s this has developed into *living history*, where museum guests can dialogue with characters who, in replicas of original costumes, portray or re-enact the past – a type of immersive, life-sized 3D theatre in a museum setting.

All the Scandinavian museum pioneers were fascinated with the village and peasant cultures whose buildings, ways of life and traditions were

under grave threat from the bulldozers of progress. But rural and agrarian culture was not alone in facing this threat. The old culture of the merchant towns with their craftsmen, merchants and shop-keepers was also seriously in decline. Quite often, when something is about to disappear it ends up in a museum – and where endangered urban culture was concerned, Peter Holm championed the cause.

The dream: a merchant-town museum

Peter Holm's own memoirs reveal that very early on, clearly "the ultimate goal had to be a merchant-town museum. [...] The other open-air museums existing at the time had only dealt with with rural culture. Here, our desire – in our brightest moments – was nothing less than to create a monument to urban middle-class culture". Holm was himself a child of a merchant-town world, which he saw rapidly disappearing. As the son of a crafts-man, he was acutely aware that middle-class urban culture was not held up by prominent merchants alone.

"There were many others, first and foremost crafts-men in their more or less humble homes, often so small they contained just one living room, a tiny kitchen and the workshop."

In his Danish book *Den Gamle By i Aarhus* ('the old-town museum in Aarhus') Peter Holm described his underlying idea:

"For me, the main thing was to create a townscape, preferably with all the cosy corners and the ambi-ence that little, old towns could have – with houses from different eras, winding streets and little gardens with fruit trees, herbs and vegetables and

Aarhus Museum, founded in 1861, spent its first few years in attic rooms above the town hall. In 1877 it moved into new, purpose-built premises, which were enlarged in 1891 with two side pavilions. The art collection was displayed in the finest rooms, followed by the collection of prehistoric artefacts. Lowest in the hierarchy came the more recent objects – the neglected collections Peter Holm took over after joining the board of Aarhus Museum in 1907. Photo taken around 1902.
|| Den Gamle By

ornamental shrubbery. At any rate, we agreed that it was not to be a museum of buildings, with rows of houses ordered systematically by style [...] For one thing, that sort of typological museum would be exceedingly boring, and for another, it could never truthfully portray an old merchant town."

The total cost of moving and re-erecting the Mayor's House, in a more durable form than at the National Exhibition, was estimated at 30,000 Danish kroner. In 1910 the town council of Aarhus granted the project 10,000, followed by another 10,000 from the national government in 1911, and a veritable flood of private contributions soon proved that the total amount was within reach.

Meanwhile, there was the ongoing task of finding the right location. The original plan was to make the Mayor's House a part of Aarhus Museum, re-erecting it as an annexe to the existing museum building, which held the town's art collection and a

historical–archaeological section. This plan was rejected, however, by Consul Ollendorff, with a board majority.

It is ironic that today, in hindsight, we are grateful to Ollendorff for spoiling the plan seen back then, by Holm and his supporters, as the best and most realistic course. Squeezing in a timber-framed building from 1597 against the stylish lines of the classicist museum building from 1877, right in the heart of Aarhus, would have been an architectural catastrophe. What is more – and even more importantly – the intended location would have precluded the addition of other historic buildings, rendering impossible the expansion which, over the next few years, would grow into the merchant-town museum, Den Gamle By.

After the museum board rejected the plan, the case was clear-cut: The Mayor's House would have to become an independent museum. After studying alternative sites, in late 1912 the town council permitted the permanent relocation of this structure, along with a few other historic buildings, to the recreational area near the centre later known as the Aarhus Botanical Garden.

The new Mayor's House officially opened about a week before the outbreak of World War I (1914–1918). Events held on 23–25 July 1914 drew people from near and far: prominent figures from Aarhus, supporters from across Denmark and "from neighbouring countries". Soon after, Director Sophus Müller of the National Museum came for a tour of the Mayor's House. As Holm recalls, the two were standing out on the open gallery when Müller asked: "Are these boards, upon which I stand, from 1597?" "No," Holm replied, to which Müller gave his often-quoted response: "So, imitation it is."

So much for ceasefire and reconciliation.

Stone Age axe heads – perhaps the most iconic objects in any classic Danish museum of prehistory. They were often shown in long series at the Norse Museum (later the National Museum) and in other museums opening in large merchant towns across Denmark from the mid-1800s. Here, axe heads from the Neolithic period.
|| Arnold Mikkelsen/ National Museum of Denmark

Prehistory

The Wunder- kammer and its descendants

Peter Holm's fight for the Mayor's House followed a centuries-long history of museums in Denmark, resembling that of many other European countries. The earliest ancestor of the museum is the cabinet of curiosities, or *Wunderkammer*. Known by various terms in Antiquity, the Middle Ages and the Renaissance, these were special collections of things that were odd, intriguing or inexplicable – curiosities – along with ancient artefacts and rare or precious objects. Not surprisingly, such collections were often owned by kings, churches, nobility and wealthy collectors.

The foremost collection of this kind in Denmark was the Royal Cabinet of Curiosities, from which grew a number of museums in the 1800s. The largest of these was Oldnordisk Museum ('the Norse Museum' of Danish prehistory), which in 1892 became the National Museum, by far the country's

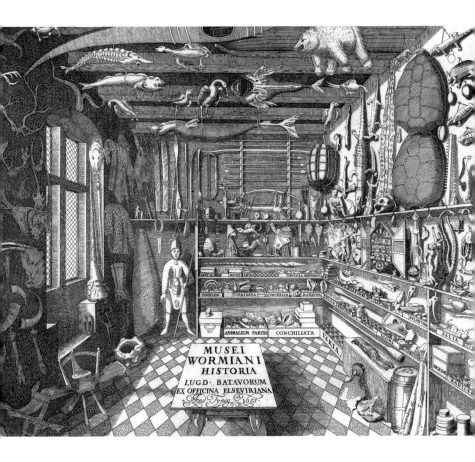

MUSEI
WORMIANI
HISTORIA
LUGD · BATAVORUM
EX OFFICINA ELSEVIRIANA
Acad Typog. 1655.

This old copper-plate title page from the *Museum Wormianum* catalogue clearly shows the sort of contents typically found in a classic *Wunderkammer* or cabinet of curiosities. The natural and ethnographic objects on display are arranged in a manner that is hard for a modern mind to comprehend.
|| Wikimedia Commons

largest and most important cultural museum. In parallel, a number of other museums arose outside Copenhagen based on citizen initiatives. They were, in part, a protest against the centralisation that persisted after Denmark's age of Absolute Monarchy (1660–1848). Their main focus was prehistory – Denmark's glorious ancient past – not the history of farmers and common folk. Still, for the first time they made it possible for ordinary people, even outside Copenhagen, to visit a museum and learn about their country in ancient times.

But back to the Royal Cabinet of Curiosities. If we call it a museum (and it would be unfair not to), it is definitely Denmark's oldest. Its history goes

back to the Renaissance, probably even further, but it only formally took shape under Frederik III (1609–1670, reigned 1648–1670). In his day the Cabinet of Curiosities was merged with Museum Wormianum, the extensive private collection of a Danish physician, ancient-object enthusiast and polyhistor named Ole Worm (1588–1654). The combined collection was so large and important that it merited, required, a building of its own, so in 1673 it was moved to new premises next door to the king's palace in the heart of Copenhagen.

A cabinet of curiosities was a place full of things. Museum objects. Besides the pure status of possessing these things, the owner's aim was to seek fascination and inspiration in what was beautiful, extraordinary, alien, rare or different. A royal collection's target group was the monarch and his family, plus selected guests. This was definitely not a museum for the people.

During the 1700s and 1800s, the *Wunderkammer* model became increasingly outdated, chiefly for three reasons. First, the Enlightenment and the growth of nations and peoples made the education of commoners an important new purpose. Second, specifically for Denmark, the loss of Norway (in 1814) and the duchies of Schleswig-Holstein (in 1864) made the country more uniformly Danish, creating a need to establish a commonality of Danish culture and history. Thirdly, generally speaking the new age hailed factual categorisation and modern systematics. This made the *Wunderkammer* look increasingly like a messy old attic, too dusty and fusty to fulfil the needs of a new age.

The 1800s saw the Royal Cabinet of Curiosities split up and spread out, its collections becoming the cornerstones in several of the mainly state-owned

museums which, even today, remain prominent in Denmark.

The Danish royal family's private collections, which had always been part of its cabinet of curiosities, became the Rosenborg Castle Museum in Copenhagen, which was opened to the public in 1838 and is still open today. Rosenborg, a pocket-sized Renaissance palace built in 1606–1634, shows a number of royal interiors, making it the country's first museum of interiors – although its main attraction is the crown jewels.

Besides Danish art, the royal cabinet's paintings included valuable collections from Italy, the Netherlands and Germany. The new Royal Gallery opened to the public as early as 1827, and its collections became the nucleus of the National Gallery, housed from 1896 in a new museum building in Sølvgade street, near the city's old ramparts – still its home today.

In 1862, the large natural-history collections became the backbone of the Zoological Museum, which after a century in central Copenhagen moved to new buildings near the university campus in 1970. Another part of the natural-history collections grew into the Botanical Museum, and the last third became the Geological Museum. Both moved, in 1877 and 1893, respectively, into new buildings by the new Botanical Garden, also laid out along the old ramparts.

The royal cabinet's collection of portraits were moved to the then newly restored Frederiksborg Castle in North Zealand, where they remain today as a significant part of the Museum of National History. Established by the founder of Carlsberg, Brewer J.C. Jacobsen (1811–1887), who was interested in history and saw a need to create a collective national consciousness in Denmark, the museum at

Frederiksborg Castle opened to the public in 1882. Today, it is the only direct descendent of the Royal Cabinet of Curiosities not owned by the Danish state.

In addition, the royal cabinet gave birth to the Royal Collection of Coins and Medals, the Collection of Classical Antiquities, Ethnographic Museum and, last but not least, the Norse Museum – dealing with Danish prehistory – which at times supervised these three others, its closest siblings.

The Norse Museum

The Norse Museum (officially 'the Royal Museum for Norse Prehistoric Artefacts'), would become the nucleus of the country's new National Museum a century later. Although likewise rooted in the Royal Cabinet of Curiosities, the Norse Museum was mainly the brainchild of the Royal Commission for the Preservation of Danish Prehistory, established in 1807. This body – known as the Prehistory Commission – grew partly from the new Romanticism's fascination with prehistory, and partly from the fact that Denmark's ancient monuments were under threat from the pervasive modernisation of agriculture after sweeping rural reforms in the late 1700s.

The Prehistory Commission had three main tasks, embedded in the Norse Museum and later the National Museum. The first: to identify and protect Denmark's existing prehistoric monuments. The second: to convey the importance of properly protecting ancient relics and artefacts. The third: to found a museum that could keep and display such artefacts 'for the public benefit'. Such a museum was founded, housed at various addresses in Copenhagen until 1854, when it moved into a complex in central Copenhagen called the Prince's Palace

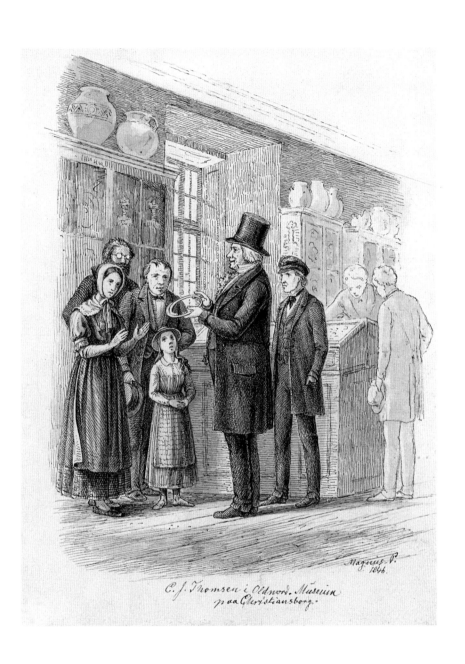

C. J. Thomsen i Oldnord. Museum
paa Christiansborg.

– the home of its modern descendant, the National Museum.

The unrivalled figure behind the Norse Museum (and Denmark's entire family of state-owned museums until the mid-nineteenth century) was a prominent Copenhagen merchant and collector named Christian Jürgensen Thomsen (1788–1865). From 1816 until his death, based at this museum, Thomsen directed several offshoots of the Royal Cabinet of Curiosities. Above all, 'Old Thomsen', as he came to be known, was a practical, hands-on leader. He did registration work himself and introduced new, systematic documentation principles for Danish prehistoric artefacts and other collections under his remit. One of his innovations was to distinguish between the kind of history one could study in written sources as opposed to prehistory, which could only be studied through preserved objects and other material remains. He did not write much, but he famously introduced the revolutionary categorisation of prehistory into three periods: Stone Age, Bronze Age and Iron Age.

Thomsen believed one of his crucial duties was to share the collection, and his own knowledge of it, with others. As early as 1819 he made it publicly and freely accessible, and he loved to take people through the museum, quickly gaining renown as a phenomenal communicator. Once a week, Copenhageners and visitors to the capital could enter, and Old Thomsen would be there in person to explain. This made the prehistoric collection a 'public benefit' for the roughly 10 per cent of Danes living in Copenhagen, plus occasional visitors. Inversely, the 90 per cent living outside the capital had a slim chance of ever seeing or hearing the tales and details that Thomsen, the celebrated storyteller, so wanted to share.

After Thomsen died in 1865, the archaeologist Jens Jacob Asmussen Worsaae (1821–1885) took over as head of the Norse Museum and the other museums Thomsen had led. Worsaae, an excellent administrator and scholar, also had the will and skill to collaborate and build institutions, and he became the second great figure in the Norse Museum's history. He was actually a scientist and the founder of Norse research as an independent field. In his book from 1843 on Denmark's ancient history "detailed through prehistoric artefacts and barrows", Worsaae was the first ever to describe prehistory based on archaeological finds. Consequently, he rejected the literary sources, legends and sagas, previously the primary basis for describing the development of societies in the ancient north. It was also Worsaae who in 1873 initiated the first systematic registration of prehistoric monuments in Denmark.

Although his field was prehistory, Worsaae was by no means narrow-minded. He held that to understand the present, just like a written history a museum of cultural history ought to "shed light on *all* preceding eras, not least those upon which rests, directly, the entire development of the present."

Unlike Sophus Müller – the next grand old man of Danish state-owned museums – both Thomsen and Worsaae mastered the art of diplomacy. They also favoured dialogue, engaging with the new museums emerging across Denmark, especially in the important towns in the provinces.

Local museums on the rise

The 1800s brought great change. In Denmark, Absolutism was superseded by popular rule. The market economy won ground, and individualism – making everyone responsible for their own happiness – superseded the communal groupings of old – which,

although safe and secure, had hampered free initiative. What is more, in 1864 the brief but bloody war with Prussia had made Denmark a small state in Europe. This left a much more homogeneous country that had to get back on its feet, creating the need for a new identity, nationally and, not least, locally, where townsfolk were gaining new self-confidence and influence.

Promoting a national identity by means of Denmark's glorious prehistory now became an ambition for the wealthier merchant towns, influential public officials and enterprising business people. Thus far the budding national consciousness had mainly come from the top down – promoted by the state. Now it also began to grow from the bottom up – from the citizens.

The earliest museums outside the capital were born in the 1850s and 1860s. First came the museum in Ribe (Southwest Jutland, in 1855) followed by Odense (Funen, 1860), Aarhus (East Jutland, 1861), Viborg (Central Jutland, 1861) and Aalborg (North Jutland, 1863). Old Thomsen, the patriarch at the Norse Museum, referred to the new institutions as "my grandchildren" and worked well with the men – for they *were* all men – running the new museums. Artefacts were exchanged, and Thomsen supplemented their collections with gifts, loans and sometimes plaster-cast replicas as well. Collaboration continued after Thomsen died and Worsaae took over in 1865, concluding the first wave of museum-founding outside Copenhagen with Randers (East Jutland, 1872) and Maribo (the southern islands, 1879).

These new provincial museums, seven in all, were almost like small national museums, founded in much the same spirit as the Norse Museum: a wish to preserve, display and convey a glorious

shared, ancient past and help create a new, shared national identity. This wish was not based on local history, nor did it revolve around the history of ordinary people.

But Denmark's local museums were driven by more than historical interest and a national ambition. There was also a political undercurrent, expressed in 1866 by one of the movement's staunch supporters in Aalborg, the teacher Johannes Forchhammer (1827–1909), who saw the new museums as a counterweight to the capital-centricity that had shaped Denmark since Absolute Monarchy began in 1660. Abolished in 1848, Absolutism had given Copenhagen pre-eminence as the permanent seat of king and court, administration and military power. The rest of the realm, called 'the provinces', was essentially marginalised: no power, no wealth, no central administrative functions. The Absolutist elite saw Copenhagen as the nucleus of the kingdom. The hub of order and rationality. The provinces remained untilled soil, their populations untamed masses awaiting cultivation.

The very term used by the central administration for these new local institutions, 'provincial museums', must be seen in this light. Objectively, 'the provinces' simply meant 'the lands outside the capital'. But more than the geographical denotations, the connotations are those of a backwater topography that lacks significance. Despite Denmark's modest size, a comparison with the Roman Empire is not entirely out of place: the 'provinces' were Rome's conquered lands, far removed from her historical and geographical centre. Their role was to submit, accepting exploitation. In Denmark, it was only in 1910 that influential figures began using the word 'local' instead of the pejorative 'provincial' in a museum context.

Aarhus Museum's most important room with prehistoric artefacts, around 1900. At the centre, a bust of J.A.A. Worsaae, director of the Norse Museum from 1865 to 1885 and the leading figure in Denmark's museum administration. Worsaae worked well with the 'provincial' museums, which numbered seven in all at time of his death, in 1885.
|| Den Gamle By

Denmark's new museums were part of a provincial push-back against a centuries-old culture of central administration. Passive obedience, the ideal under Absolutism, was replaced by a focus on active, engaged, responsible citizens. The people behind the new local museums were certainly good, upstanding citizens, but they were no longer willing to accept a Copenhagen-based monopoly on the history and formation of Denmark in the new age.

As Forchhammer said in 1866: "It is no longer acceptable that Copenhagen is all, and the merchant towns nothing."

Let us look at Aarhus, where the local museum was founded in 1861 by a group of townspeople with a special interest in history. Within the year they were able to display a museum collection in the new town hall, built in 1857, which already housed the town's art collection. In December 1861, some six months after its inception, we have the first description of the museum in a local newspaper:

Few people from the provinces had access to see the collections in Copenhagen, and "therefore in this matter, as in many others, those living in the provinces are as stepchildren compared to the Copenhageners." Hence, it was only fair "that also in the country's large merchant towns things can and should be done to educate the people." The writer was pleasantly surprised to see "perhaps more than 150 persons" studying the displays, remarking that several of the board members "were constantly in motion, presenting and explaining the pieces."

In 1870 the Historical Antiquarian Society in Aarhus had 65 members, eight from out of town. Like the other museums outside Copenhagen, this too was purely a citizens' initiative. Its work was financed by membership fees and charitable donations, and the workforce consisted of its members. Despite the museum's local roots, geographically its collections were much wider. Danish prehistory was the defining theme, covering all of Jutland except its northern regions, and including Schleswig in the south. Similar patterns were seen in other first-generation museums outside Copenhagen.

All the new museums got buildings of their own in the 1870s and 1880s. The one in Aarhus, opened in 1877, was to house the art museum and the Historical Antiquarian Collection. As for rooms and floor space, the art collection clearly took precedence, the prehistoric artefacts biding their time until 1881 when, finally, they were put on display in a suite of small, cramped rooms in the attic. A decade later, in 1891, the Historical Antiquarian Collection found found its home in one of the museum's two new side pavilions.

With this, Aarhus Museum came to consist of three independent institutions. The first was the 'art section', which much later, in 1967, got a build-

ing of its own outside the city centre, as Aarhus Art Museum. After another name change in 2004 – to ARoS – art moved into an impressive new building just a stone's throw from the original museum of 1877. The second independent institution was the 'history section', as the Historical Antiquarian Collection came to be known. It was this section that gradually gave rise to Den Gamle By, and in 1970 its archaeological sub-collections were moved to Moesgaard, an old manor house south of the city, of which more later. The third institution was the museum building itself, supervised by a board of representatives from the two 'section' museums.

But in the museum building from 1877 the traditional hierarchy remained intact. The art collection ranked highest, with the best rooms. Next came classical antiquities and Danish prehistory. Last in line were the modern-history collections from medieval times onwards – those entrusted to young Peter Holm when he joined the museum's board in 1907, sparking his Mayor's House project and later moving from Aarhus Museum to Den Gamle By.

By this time the Norse Museum had long since become the National Museum of Denmark. This change, formalised in 1892, signalled a new museum agenda in Denmark. In fact, in the mid-1880s control of the country's flagship museum had already been taken over by the man who, more than any other, for better and for worse, would define the rules of engagement in Denmark's cultural-history museum community for decades to come. The name of this aristocratic archaeologist was Sophus Müller.

For decades around the turn of the century, Sophus Müller categorically dictated what a 'real museum' was. Müller was known far and wide as a tough opponent, even outside Denmark. His daughter, Elin Nordman (1891–1982), once recalled how, at a gala dinner in Stockholm, one of her father's Swedish peers bluntly asked her: "So tell me, what is it like to be the daughter of 'the Dreaded One'?"
|| National Museum of Denmark

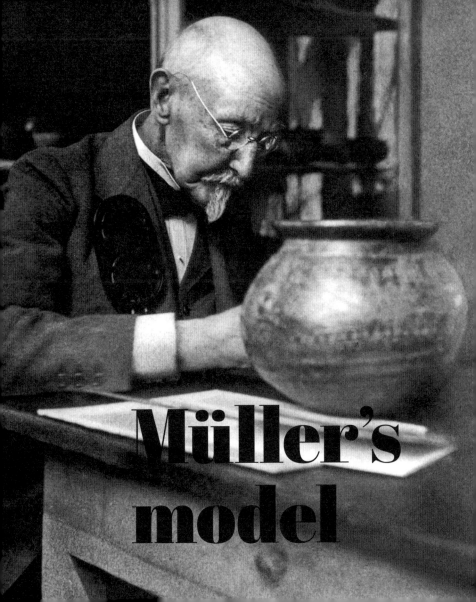

Müller's
model

Concen-
tration
of power

The conflict about Peter Holm's museum in Aarhus was preceded by a remarkable concentration of power around Denmark's state-run National Museum in Copenhagen. Prehistory and its academic field, archaeology, held the indisputable right of the firstborn. Museum work became more scientific. On the one hand this trend brought more quality to the exhibitions, but on the other hand research and the individual genuine artefacts got so much attention that the sweeping story of a people – the National Museum's hallmark since Old Thomsen's day – was pushed aside.

An instrumental force in this was Sophus Müller, the agenda-setting figure who had already taken control in the mid-1880s. It has been said of the leadership of the Norse Museum after J.J.A. Worsaae's death that the next aging director, C.F. Herbst (1818–1911), may have held the title, but that his assistant, Sophus Müller, held the reins and cracked the whip. Delving into the sources reveals nothing to contradict this. Seemingly Müller, then 40, did everything he could to control the emerging local museums. He probably never really understood this evolution, and he did his best to mould

their structures to fit his unshakable conviction of what a museum ought to be, and do.

Müller, an avowed conservative, was part of Copenhagen's old intellectual aristocracy, which in turn was rooted in the mindset and world view of Absolutism. Born in the capital in 1846, he was the son of Carl Ludvig Müller (1809–1891) and Eleonora Müller (1819–1865). His father held a doctorate from the University of Copenhagen and specialised in numismatics, reaching the zenith of his career as the director of two collections from the Royal Cabinet of Curiosities: Coins and Medals, and Classical Antiquities. Sophus Müller's paternal grandfather was bishop of the diocese of Zealand, and his father before him was the royal councillor Friederich Adam Müller (1725–1795), famed for assembling the matchless collection of copper-print engravings at the Royal Danish Library, which survives to this day as Müller's Pinakotek.

The young Müller studied classical philology at the University of Copenhagen, but study trips abroad in the 1870s drew him to prehistory. In 1878 he joined the staff of the Norse Museum, defending his doctoral dissertation on animal ornaments in the Nordic region in 1880. When director Worsaae died in 1885, Müller became de facto leader of prehistory in particular, and of Denmark's state-run museums in general. In 1892 his power was formalised when he was appointed director of the 'first section' of the new National Museum. As one of his successors, Johannes Brøndsted (1890–1965), once put it, by the turn of the century Müller was "the acknowledged crux of archaeology in Denmark." With him, "the threads were gathered" and from him "every significant initiative came." He was a champion of rigorous scientific discipline, which he

also practiced himself, and a "ruthless exterminator of laxity and amateurism."

In 1881, Müller was already in a key position as secretary of the royal Nordic society for ancient writings – and an efficient organiser of excursions. As his fellow director Mouritz Mackeprang (1869–1959) recalled: "Everything was thought out in minutest detail and planned as diligently as any general-staff campaign. [...] The program was carried out with military precision, and the participants treated exactly like recruits."

Sophus Müller was a hard man. Brøndsted called him "tough and ruthless", pointing out his "imperatorial conduct" when dealing with the provincial museums. "In his institution, an autocrat" and verbally "sharp, goading, mocking". Müller was more aristocrat than democrat. He was more a Copenhagener than he was a Dane – although he would probably have seen little difference. Also, he was more scientist than museum-builder, and more of a researcher than a teacher or enlightener. Finally, he was more prehistorian than historian.

Müller already began running the show in 1885, after the museum in Aalborg applied for an annual grant of 2,000 kroner. The ministry consulted the Norse Museum, and the reply had Müller written all over it: Only one museum ought to inform the Danes about their country's past and handle all scientific research. The provincial museums could only be entrusted with offering popular information, and in no way ought they be allowed to develop into independent scientific institutions. The Norse Museum also recommended the application sum be halved, but that a corresponding sum of 1,000 kroner be given to all seven provincial museums.

In return for public funding (the response went on), the local museums were to defer to the suprem-

acy of the central museum (Müller's museum) in various matters. Müller's model, effective from 1887, implied that the Norse Museum would supervise local museum collections and could even remove artefacts to Copenhagen. It would also have the last word on where and when to excavate, and where archaeological finds would reside. This 'pledge' also stated that any disputes were to be finally decided by – surprise! – the director of the Norse Museum.

This museum (from 1892 the National Museum) was not *primus inter pares*, 'first among equals'. It was a sovereign that held absolute power over its subjects – quite in keeping with its origins as the Royal Cabinet of Curiosities.

Bernhard Olsen and the expositions

Meanwhile, challenges to central control spread far beyond the local initiatives. Economic growth, popular support and more self-awareness in many professions gradually coalesced into new museums, inspired by the great expositions. The first events of this kind were national and regional, but with the Great Exhibition of the Works of Industry of All Nations, held in London in 1851, the concept of the world's fair had arrived. Denmark has never hosted an event of this size, but the national fairs held in Copenhagen (1879 and 1888) and Aarhus (1909) built on the same concept: faith in progress, and an appreciation of history. Their ambition: to create a window and a marketing opportunity for companies and their products, and to showcase their national culture and folklore. The expositions developed new, eye-catching ways to reach their audiences, some with the potential to enrich and renew story-telling in the museum world.

Once again taking Denmark as an example, the country's three industrial museums for agriculture,

fisheries and applied design are all rooted in the large Copenhagen expositions. Even so, the clearest links between great fair and museum are seen in the history of the two institutions founded by Bernhard Olsen: the Danish Folk Museum in 1885, and the Danish Open-Air Museum, which found its permanent home north of Copenhagen in 1901.

Bernhard Olsen had a background in entertainment, so he was used to *having* to reach his audience. An illustrator by profession, he had done work for magazines, designed costumes at the Royal Theatre and served as the art director of Tivoli Gardens. He had travelled Europe studying new, exciting ways to present material, such as entire tableaux and folklore performances. While visiting the Paris world's fair in 1878, Olsen met the museum founder Artur Hazelius and was deeply impressed by the Swede's panorama-style presentation of an entire museum collection.

Few Danes were better suited than Bernhard Olsen to be head organiser of a Copenhagen event being planned for 1879 – the Exposition of Art and Industry – under the auspices of the Industrial Association of Copenhagen. The fair's committee chairman was none other than J.J.A. Worsaae – the open-minded director of the Norse Museum – for the fair aimed not only to exhibit industrial products but historical objects as well, displayed in chronological order. The ambition was to show "a comprehensive and living picture, particularly from the time of the Reformation [in 1536] up to our day", focusing on artistic and industrial developments to inspire contemporary creativity.

Bernhard Olsen poured his energy into the work, building a huge collection of costumes, textiles, guild paraphernalia, furniture and entire rooms. In a letter from 1879, Olsen recounted his attempts to

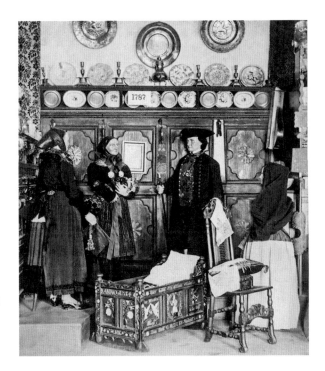

The Exposition of Art and Industry in Copenhagen is where Bernhard Olsen first used his scenography skills to narrate history. Here, the Amager Room, a complete interior with figures in local costumes. "Once the collecting is done, the road to a museum is not long," he wrote in 1879 to his friend Artur Hazelius – founder of the world's first folk museum, in Stockholm in 1873. "We shall get there eventually," he confidently added – and he was right.
|| National Museum of Denmark

"collect everything we have left over here in Denmark, in the way of old folk memorabilia. […] Once the collecting is done, the road to a museum is not long." He wrote this in a letter to Hazelius – who in 1873 had already opened the Stockholm museum that would later become Nordiska Museet. At the Copenhagen exposition in 1879, Olsen went one step further than his Swedish counterpart, whose panoramas of historic peasant rooms Olsen saw as theatrical. While Hazelius lodged his interiors within three walls, enabling the audience to look in through the fourth, open side, Olsen chose another model: four walls and a ceiling, so the light falling through the old windows could create an authentic ambience. According to the Danish art historian Julius Lange (1838–1896), "This exhibition was a particular success, constituting one of the most interesting components of the fair." Lange

also remarked on the good entertainment value in genuinely re-creating peasant homes with all the trappings – even mannequins in period dress.

The Danish Folk Museum and the Open-Air Museum

Emboldened by the success of the 1879 exposition, a historical circle formed a committee in 1881 with the purpose of setting up a Danish folk museum. The fact that Worsaae was also chairman of this committee shows that despite his scholarly preference for prehistory, he believed museums should cover all areas and eras. He saw the emerging folk museum as a necessary supplement to, and initially a partner of, the Norse Museum. The committee and Bernhard Olsen wanted the folk museum to cover the time from early Absolutism up to the mid-1800s, as a "continuation and completion of our existing historical collections." Also, while the existing collections

"most significantly include objects of real historic or artistic value, our museum will deal purely with cultural history and give a complete and demonstrative portrayal of our folkloric and provincial particularities."

A key task would be depicting the history of the home.

Following a storage intermezzo in the attic of the Trinitatis Church in Copenhagen, the Danish Folk Museum, as it was now officially named, moved into a new building not far from the city centre called the Panopticon Building – so named for the *panoptikon* or wax cabinet on the ground floor. Here, in worthy surroundings, visitors could meet effigies of royalty and famous writers, and more chilling

tableaux, including a killing at a wedding feast long ago, set inside a deep framework made of 400-year-old timber from a Norwegian farmstead.

Above this popular Panopticon lay the first Danish Folk Museum exhibition, a series of sparingly composed interiors showing the development of the home. But as the years passed and the collections grew, the 'interiors' principle became fuzzier and was veiled by the number of objects placed on walls, furniture and other available spaces.

When Worsaae died in 1885, Bernhard Olsen and the folk museum lost one of its most steadfast supporters. Much like the museums in the provinces, the Danish Folk Museum was knocked into shape, in this case by means of its own by-laws, approved in 1886. They were a result of a protracted dialogue between the folk museum, the ministry and the central museum, now in effect headed by Sophus Müller. The advantage: a fixed annual state grant to the folk museum, on a par with the provincial museums. The price: subordination.

At the bidding of the Norse Museum, the folk museum's by-laws limited its time frame to the period of Absolute Monarchy, from 1660 to 1848. Older objects were to be referred to other relevant public collections – notably the Norse Museum. In fact, the folk museum was required to extract older objects and transfer them to the national museum, and objects from after 1848 were not even discussed. The by-laws also stipulated that the folk museum was to keep

"A precise inventory, such as must be required at a museum which not only is to serve ordinary, popular information, but which additionally is to form the basis of studies of cultural history."

It was also decided that, in time, the folk museum was to be absorbed into the historical collections of the state – meaning the future National Museum, soon to be designed. But for the time being, the Danish Folk Museum was to conduct business as usual. The committee established in 1881 would become its four-member board, supplemented, importantly, by a representative of the Norse Museum, thereby ensuring central influence on the folk museum's collections and activities.

Despite the restraints, Bernhard Olsen's creative force remained intact. Inspired by the double-museum concept of his Swedish friend Artur Hazelius in Stockholm – Nordiska Museet (1873) and Skansen (1891) – Olsen began work to pair the Danish Folk Museum with a Danish building museum. Like Skansen, it would focus on rural structures, which he planned to collect across the country and also in the once-Danish provinces in Southern Sweden and the duchies of Schleswig-Holstein

Olsen's new museum opened in 1897 in a corner of the spacious King's Garden, near Rosenborg Castle. This soon proved impractical so Olsen looked for a better site, which he found in Lyngby, a rural area north of Copenhagen. The Danish Open-Air Museum opened there in 1901. Parallel to the folk museum's row of interiors, the open-air museum was to be a systematic overview of various types of farms, but over time it came to more broadly cover Denmark's rural past. Beginning as an integral part of the Danish Folk Museum, it too was destined to be absorbed into the National Museum. This link was formalised in 1920 when both of Olsen's museums were merged into the 'third section' of the National Museum, and in 1934 the collections of the Danish Folk Museum were physically moved to the Prince's Palace complex.

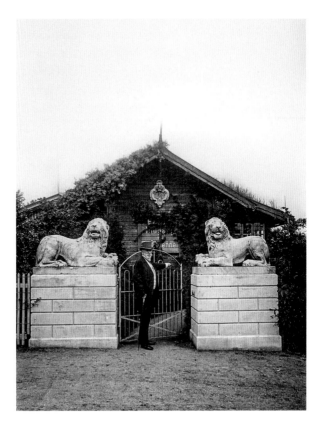

Until this formal move, the obligatory central supervision was carried out by Henry Petersen (1849–1896), who in 1892 was appointed as director of the National Museum's 'second section' (Middle Ages and Renaissance). When Petersen died in 1896, the job went to William Mollerup (1846–1917), who was fired in 1910 – again bringing our story full circle, for his successor was none other than Peter Holm's friend and ally Christian Axel Jensen, whom we met in the story of Den Gamle By's origins.

It was incredibly lucky for the folk museum and the open-air museum to have national supervisors who were interested and skilled in modern history. Jensen was particularly eminent in this field. Surviving correspondence from 1897 between Director

Mollerup and Bernhard Olsen hints that Sophus Müller hovered in the wings, yet apparently with no real power to control Olsen's two museums – though that does not mean he never tried.

Müller's damning decree

In 1897, Sophus Müller sounded the attack against the folk and open-air museums. In an article in a prominent monthly journal, he called Skansen open-air museum "Hazelius's establishment near Stockholm", and referred to the ethnographic tableaux at the great expositions as "the Bastille and environs" and "Old Berlin". He also, once, mentioned "the so-called open-air and park museums", but otherwise spoke more in general terms about "interior–exteriors". Inexplicably, Müller mentioned neither the Danish Folk Museum nor its structural sibling, the Danish Open-Air Museum, nor did he mention any of the ever more numerous local museums that were evolving into folk museums. Still, they must all have been at the back of his mind. Müller emphasised in the article that "establishments" of this sort were neither museums nor collections. Regarded from a museum perspective, he wrote, they were falsifications and entertainment for "a lethargic urban population for whom a museum holds no attraction, but who might conceivably be enticed by the interior."

Müller listed several points that barred calling such "establishments" museums. Firstly, they were different because they were based upon buildings moved from their original location. He saw building and location as inseparable, and maintained that if a building were moved it would "forfeit some of its significance or lose it completely." Secondly, he objected to the creation of "interior–exteriors" complete with rooms, houses, yards, gardens and fields.

"The partially preserved interior decorations are filled in with the lacking portions, such that the addition cannot be distinguished from the original. Where no genuine elements are had, copying is done. If, in turn, there is nothing to copy, then imitation and invention are done. [...] The interior–exteriors are thus not collections of original items but are, to a greater or lesser degree, imitations or new creations. The copies [...] profess to be genuine. In other areas, this is termed falsification."

Müller thirdly argued that much of what these "establishments" acquired was trivial: "memorials of negligible significance, such as buildings from countryside and merchant town" along with all sorts of common items, thingamabobs and memorabilia that should not be preserved, and which "do not belong here". While museums belonged to the realm of science, "the interior–exterior portrayals of reality" belonged to the realm of art. A museum primarily addressed thought and intellect; interior–exteriors addressed mood and emotion:

"The conjurer of interiors would present reality in a similar way as the art of theatre does, as do paintings and the art of poetry."

Müller held that "interior and museum are, between them, so incongruous that they cannot possibly be united in the same institution," hence "all original artefacts ought to be relinquished to the museums, where they belong, and art would operate solely with imitations."

The battle over applied art
The Danish Folk Museum and Open-Air Museum

grew directly from the Exposition of Art and Industry in 1879. Similarly, the Copenhagen exposition in 1888 gave rise to museums of agriculture and fishery, trade and industry. Officially called the Nordic Exposition of Industry, Agriculture and Art, the 1888 event was the culmination of Danish trade-fair tradition. It was also a high-profile show of strength for the Nordic business community with thousands of stands, and tens of thousands of exhibition numbers. In its 138 days, this great Nordic fair attracted nearly 1.4 million visitors, almost five times the capital's population. More than anything, it brought new self-confidence to several professions which, in the emerging modern society, were gaining independence and economic importance.

Just a year later, in 1889, this led to the founding of the Danish Agricultural Museum, associated with the Agricultural School in Lyngby, north of Copenhagen (near the Open-Air Museum). A fisheries museum also followed as an offshoot of the 1888 fair's section on fishery, but it never really caught on and was surpassed many years later in this field by other, similar museums outside Copenhagen.

Other efforts were more successful. One was a plan for an applied-art museum, championed by the industrial historian Camillus Nyrop (1843–1918), secretary of the Industrial Association of Copenhagen (today's Confederation of Danish Industry). Writing in 1889, Nyrop argued that a Danish museum for applied art and design must be ambitious, containing a library as well as collections of objects, which, historically, ought to show "the special characteristics for the individual countries, periods and factories." The target audience would be practitioners of trades and crafts, manufacturers, journeymen and apprentices who wanted to learn about styles and techniques from different periods and

cultures. Such a museum would also differ from the existing state-run collections – which Nyrop found boring, with their endless rows of uniform objects.

Sophus Müller did not agree. In an article published in 1890 in the applied-arts trade journal (which Nyrop edited), Müller launched yet another attack, this time on Nyrop & Co's ambitious plans. Basically, Müller underscored the supremacy of the old collections, claiming "that surely anyone would prefer, as now, to have everything gathered in one place," meaning in the old existing collections rather than in some new museum. In his response, Nyrop argued against Müller's "unbending stringency," noting that Müller essentially said there was no room for new museums, or for any other way of structuring a museum. The verdict: the existing museum system was sacrosanct.

Sophus Müller prevailed, joining the committee that would define the scope and activities of the new museum, which – in the words of the museum's later director, Emil Hannover (1864–1923) – were "the narrowest ever granted a museum." Müller made sure the new museum would devote itself to "contemporary applied art and design, in Denmark and abroad, beginning at the turn of the century." The museum opened to the public in 1895, so it had obviously relinquished original objects from former times and other places that were represented elsewhere in "the capital city's public collections." That year Müller also took a seat on the board of the new museum for decorative and applied art. As ministerial supervisor, he was to ensure that it stayed within its mandate.

The constraints softened, but the museum still mainly shows Danish and international decorative and applied art and industrial design from the nineteenth and twentieth centuries. After three decades

in a nondescript building near Tivoli Gardens, in 1926 the museum moved to its current location: the eighteenth-century Royal Frederiks Hospital in old Copenhagen. Designmuseum Danmark, so named since 2011, is now an independent museum supported by the Ministry of Culture.

The National Museum of Denmark

It was Sophus Müller – powerful, ambitious, in character – who presented the plan for a national museum to the appropriate minister in 1887. His proposal was realised in 1892, dividing the new central museum into two sections of equal standing, at least in principle, with one director each.

Müller was appointed director of the 'first section' – once the Norse Museum, and indisputably the new museum's prime section. Besides the legacy museum's Danish prehistory collection, the first section contained subsections for classical antiquities and ethnography, and it also supervised the provincial museums. The new 'second section' was clearly second in importance. It contained the legacy museum's smaller but important medieval and Renaissance collections, and its first director was the archaeologist Henry Petersen, who died unexpectedly in 1896. His successor, the historian William Mollerup, was dismissed in 1910, but his replacement, a historian and avid scholar named Mouritz Mackeprang, slowly brought a new balance to Sophus Müller's near-absolute rule. When Müller retired in 1921, Mackeprang stepped in as joint director for the whole National Museum, a post he held until 1938.

In 1920, according to plan, the Danish Folk Museum and the Open-Air Museum were integrated into the National Museum as its 'third section', theoretically uniting the entire history of Denmark in

one institution. In practice, however, actual integration only took place when the folk museum moved into the Prince's Palace after Mackeprang's expansion of the complex in the early 1930s.

Despite its size and scope the National Museum was chiefly a museum of prehistory and archaeology, boasting a scientific prowess in prehistoric archaeology fostered by its early directors Christian J. Thomsen, J.J.A. Worsaae and Sophus Müller. This uniquely strong triad developed key principles for chronology, excavation, typology and artefact interpretation that remain fundamental in their field. The National Museum was Denmark's centre of prehistoric archaeology, for although historical studies had long been an independent academic field at the University of Copenhagen, prehistoric archaeology did not gain a similar status until 1930, having previously been seen as a sort of apprenticeship study under the auspices of the National Museum.

Müller's vision was one universal museum: the National Museum in Copenhagen. A scientific powerhouse overseeing all other museums in the fields of archaeology, history and ethnography. A repository for all objects significant to Danish prehistory, prehistoric artefacts spanning Europe and the classical cultures, and ethnographic collections from around the world. Müller believed all important objects belonged at the National Museum, as did all related research. Copenhagen was plainly the centre of the realm, the essence of Denmark in its entirety. Müller often voiced such sentiments, perhaps most memorably in 1910 at a meeting in the East Jutland town of Randers, where the National Museum was discussing its work with museums across Denmark. Probably not even meaning to offend the population of any specific remote area, he used some of the 'locals' as an example – although

his rhetorical question referred to a whole different region: Northwest Jutland.

"Are you [locals] saying it is unjust that you should travel to Copenhagen to see your ancient artefacts? If so, we [Müller and the National Museum] say it is more unjust that we should journey to [the Northwest] to see ours. For the ancient artefacts from your homeland are the antiquities of our nation. The loam in which they were found belongs just as much to Denmark as it does to [the Northwest]. We [at the National Museum] are the only ones who have our borders properly delimited [...]. Our museum covers all the people of Denmark."

Müller's reprimand reflects the main point in a 1996 doctoral dissertation entitled *The Discovery of Jutland – The regional dimension in Danish history 1814–64*, by the historian Steen Bo Frandsen (b. 1958). He describes how, after losing the war (and southern duchies) to Prussia in 1864, Denmark

took a course of forced centralism, streamlining the whole country on the capital city's terms. Copenhagen, growing like never before, took all the institutions and reduced the rest of the country to an exploited province, culturally and economically:

"It remains the privilege of Copenhagen to have everything right around the corner and let others pay the subsidies, referring to [the importance of] 'national' arrangements."

Sophus Müller's eternal struggle for central control was, of course, linked to his aristocratic, capital-centric world view. Not surprisingly, this was typical in academic circles, where all degrees were earned in Copenhagen – then Denmark's only true city, with both a cathedral and a university. Still, there was another crucial factor: Müller's unbending ambition of excellence and expertise in all scientific and museum-based work.

Swearing to objectivity
In the late 1800s, the scholarship of history and archaeology became scientific disciplines, following the empirical approach established in the natural sciences. In this approach there is only one reality – objective reality – which can be seen, heard, weighed and measured. Emotions, religion, ethics and connections that cannot be ascertained and documented have no place there. Nor do personal scholarly interpretations.

For academic fields like archaeology and history, this unshakable faith in objectivity meant distinguishing sharply between the scientific analysis and the cohesive narrative. In a scientific investigation, whether of an individual object or archival sources, the researcher examines and assesses objective,

provable facts. The scientific work then forms the basis of the representation: the historiography. This last step, however, lay outside the realm of scientific work and was more like a literary genre.

The first consequence was that the representation – the narrative communication – lost priority. Sometimes it was even scorned, at times so harshly that the cohesive narrative was completely left out on purpose. This was true not only of written histories but also of the way exhibitions were composed. The historians would concentrate on publishing authoritative pieces or doing in-depth detail studies that emphasised testing the sources. The museum's archaeologists focused on exhibiting long series of similar objects. Both practices chiefly benefited colleagues and experts in the field.

It is a fair point that archaeology and historical scholarship did gain credibility, as their results were based on critical scientific analysis. On the other hand, the tight corseting of such research – to borrow a phrase the Danish ethnologist Palle O. Christiansen (b. 1946) used to describe this trend – suppressed the narratives that could glue together the documented knowledge and bring a wider understanding to people outside the narrow circle of experts. The trend affected both archaeology, where Sophus Müller ruled supreme for decades, and historical scholarship, where the historian and professor Kristian Erslev (1852–1930) was enormously influential. Therefore it is also a fair conclusion that in pushing the wider narrative aside as unscientific, the 'scientification' of museum scholarship and study actually, inadvertently, threw the baby – the story, the cohesion – out with the bathwater.

Most of the local museums that emerged in the early 1900s displayed 'things' – especially from modern history. If the brief labels mentioned 'people' at all, it was usually the names of the donors. Here, the interior of the re-created local museum in the 1927 section of Den Gamle By. Exhibits range from stone axe heads and plaster casts of the famous Golden Horns to country-style textiles, maternity crocks and a delftware platter donated by "Mrs. Steamroller-Operator Nielsen".
|| Den Gamle By

FORRIGE · AARHUNDREDE

Modern times

By leaps and bounds

In 1916, in the wake of the dispute at Aarhus Museum, Sophus Müller lost the battle over state funding to help operate Peter Holm's new open-air museum. Müller was against sending money, but in vain. This was one sign of a new era for the National Museum, and for Danish museums at large. The shift coincided with a gradual balancing out of Müller's power plays by Mouritz Mackeprang, his fellow director from 1910 onwards. As mentioned, from 1921 (when Müller retired) until 1938, Mackeprang was the National Museum's sole director.

While Müller had fought to defend a hierarchical model of his own devising, Mackeprang sought dialogue and new ways forward, thereby ensuring that the National Museum's key influence on prehistoric and archaeological collections and research remained unchallenged in his day. His successors from 1938 to 1960 – Poul Nørlund (1888–1951) and Johannes Brøndsted – did likewise.

Denmark's museums continued to proliferate, and differentiate. Many focused on ways of life and professions which, although dramatically changing or even disappearing, were still widely regarded with some nostalgia.

The main chronological focus was on what historians call 'modern history', here referring to the

time after the Reformation in 1536 and especially to Denmark's Absolutist period from 1660 to 1848. As far as material goes, the objects from this period far outnumber prehistoric and medieval artefacts.

On state funding
The battleground of 1915 was once again Aarhus, where the committee working to preserve the Mayor's House had applied to the Ministry of Education for operational funding. They estimated the annual operating costs at 4,500 kroner, asking the national and local authorities to cover one third each, assuming the rest could be earned through a small entrance fee – 25 øre for adults and 10 øre for children.

Now, applying for an annual state operating subsidy of 1,500 kroner shows that Peter Holm knew his worth. First, state subsidies were only granted to very few provincial museums. Second, they only received 1,000 kroner, 'they' being Aarhus Museum and a good handful of other museums doing archaeological work. Third, at the time it was extremely optimistic to assume that a museum's own income could cover a third of operating costs.

The ministry asked for the National Museum's opinion of the application, revealing a rift between the two museum-section directors in Copenhagen. Documents in the archives of the National Museum and Den Gamle By show that Müller and Mackeprang chose to send separate responses to the ministry, and they also chose to *send* their responses to each other rather than meeting in person, suggesting they were not on speaking terms.

Sophus Müller's response to the ministry is one long notional, almost museal–philosophical vilification of Peter Holm's project – "15 closely written pages" of it, as Holm bitterly wrote in his memoirs.

Here, Müller distinguished between "what is central, which has a claim on public support; and what is peripheral, which does not [...] To the central belongs that which is authentic and true; to the peripheral that which is inauthentic and untrue." In his view, the Mayor's House, meaning the building and the interiors, were inauthentic and untrue. Not only had the building been moved from its original location. It had been reconstructed. As for the interiors, they had been created using objects of varying provenance. In fact, Müller was even unwilling to call the Mayor's House an "imitation or copy", but saw it as a freely assembled outfitting of "random constituents collected from all manner of places". He also disparagingly mentioned that the Mayor's House contained "items all the way down to the time of our parents," then compared it with a historical novel:

"It too stays as near as possible to the truth, and indeed, much is actually taken directly from the accounts. But where the substance was lacking things have been made up, and as for the details, well, little is known."

He accentuated his views by comparing the Mayor's House to "public amusements" at large, which by no means merited state funding.

Considering Müller's response today, it was a brazen attack on a man known for his historical interest and insight, his personal integrity and his work for the public good – who incidentally received the title of honorary doctor several decades later at Aarhus University, founded in 1928.

Mackeprang took a very different, more level-headed view in his response, explaining how the National Museum's second section had followed

Peter Holm's work. He regarded the rebuilt Mayor's House and its cavalcade of interiors as "exceedingly skilful and credible work", supporting Holm's ambition to portray "the development of a Danish merchant town's citizenry and occupational life from around the year 1600, with a particular view to Aarhus." Also, he wrote, Holm's initiative merited thanks, as existing provincial museums, with few exceptions, had only "completely unplanned and random collections of objects from this period." Even at this stage, he went on, the Mayor's House surpassed "by far the other provincial museums," so he recommended the state look favourably on the application.

In short, Sophus Müller's camp lost the power struggle over museum policy. In a letter dated 1 April 1916, the ministry approved the application, granting Holm's project an annual 1,500 kroner for operating costs. Once state funding was secured, the local authority also signed up – and the Mayor's House became a permanent museum with a stable, twofold financial base.

The museum boom

Denmark saw new museums pop up across the country in the decades around 1900, from north to south and east to west, in towns large and small. Even Herning, then just a large village on the Jutland heath, set up a museum in 1892, over twenty years before formally earning the status of merchant town. In Copenhagen, too, a group founded a local urban-history museum (in 1901), but it was overshadowed by the capital's many large national museums.

While the old, first-generation museums had cultivated Denmark's glorious ancient history, the new museums focused on the history of country

folk and townspeople, and the history of ordinary people came to define Danish identity. This history was not concentrated in one place, but unfolded locally, across the country.

Soon after Mackeprang became director at the National Museum in 1910, he explained his view: The main task of local museums was "to educate the people", their collections serving as "a good book for the people, which gives visitors insight into the way in which Danish culture has played out during the various times in the various parts of our country." In light of Mackeprang's positions, there was surely a political point in using 'local museum' rather than the often derogatory 'provincial museum'. Still, he felt it was vital to assert that the only task of local museums was to collect local objects and material. In this context Mackeprang specifically mentioned folk costumes, guild objects, uniforms, banners, engravings and topographic paintings – which arrived along with ploughs, flails, linen-working and farm equipment, maternity crocks, mangling boards and embroidered samplers: once-useful items now obsolete, but still fondly remembered. Mackeprang's point was that local museums ought to stick to local history, recent centuries and the history of 'ordinary people'. Like prehistory and research, extraordinary objects still belonged at the National Museum.

When the Danish state made its 'pledge' with the early provincial museums in 1887, their number was seven. By the turn of the century there were 15, growing to 30 local museums in 1910. In 1914 there were 41, swelling to 77 by 1930. These included the 4 local museums in South Jutland that had returned to the Danish realm (and the Danish museum world) in 1920, after Germany's defeat in World War I and the subsequent regional referendum and

Reunification. The statutory order anticipating the Danish Museum Act of 1958 states the total number of local museums outside the capital at 116. The three existing local museums in the Copenhagen and Frederiksberg metro area made for a grand total of 119.

The new museums, by no means public projects, grew from the grassroots up. Most started as citizens' initiatives based on a museum association or historical society or, just as often, on a zealous founder. Most museum work was done by committed volunteers. Some museums slowly began to get funding from local authorities, typically as rent-free premises or rent subsidies. In the mid-1950s, more than half of museums received less than 1,000 kroner in municipal funds. A dozen local museums received more than 10,000, but only the old museums in the regional centres Odense, Aalborg, Aarhus and Haderslev were getting 50,000 or more in municipal operating grants. In the mid-1950s, 33 museums were receiving national funding, but even the 'large' state grant, approved for 21 museums, was just 2,600 kroner per year, nowhere near municipal levels. The 12 museums receiving the 'small' state grant got a mere 1,300 per year, making it obvious that national museum funding in Denmark was more a symbolic gesture than real financial support.

Although local museums had grown from the grassroots and most dealt with the history of ordinary people, they were not attractions. Not at all. With a few notable exceptions, in the mid-1900s annual visitor numbers were below 10,000, often lower than 1,000. The exceptions lay in Odense (15,000), Aalborg (25,000), Aarhus and Herning (with 10,000 visitors each), eclipsed by the impressive town castles Koldinghus and Sønderborg

Initially, few museums had a truly local profile. One exception was the museum in Herning, which soon began focusing on life on the heaths of Central Jutland – from primitive heathland farms to knitwear and the textile industry. Here, a view of the re-created *bindstouw* ('knitting room'), still found at the museum today, showing the domestic industry that sparked the town's textile boom.
|| Kjeld Hansen/ Museum Midtjylland

Slot (57,000 and 48,000, respectively), which were national attractions in their own right.

A few local museums, typically in the larger towns, began to employ academic staff. In Odense, the historian Svend Larsen (1905–1964) was first employed as an assistant, then promoted to museum head in 1939. In Aalborg, the archaeologist Peter Riismøller (1905–1973) was taken on as a contracted curator in 1936, offered a permanent position in 1945, and promoted to museum director in 1960. In Aarhus, the archaeologist P.V. Glob (1911–1985) joined the museum in 1949 in a split or dual position: half as professor of archaeology at Aarhus University, half as the head of Aarhus Museum. Every rule has an exception, in this case the mid-Jutland town of Herning, where the museum took on its first professionally skilled head, the conservator Hans Peter Hansen (1879–1961), as early as 1915.

Detractors of the local-museum concept might say that many local collections were 'a bit of everything, but not much of anything'. Firstly, these museums had limited capacity and resources, and secondly, most merchant towns and their catchment areas were, after all, fairly similar. But once again, there were exceptions, the best of which, once again, lay on the Jutland heath, in the town of Herning.

On the Jutland heath

As early as 1892, amid the wide heaths of Jutland, a country teacher named Jens Andersen Trøstrup (1830–1915) founded a museum. He simply applied his callipers to a map to find the Danish mainland's geographical centre. Pinpointing the village of Herning, he had his location. Trøstrup's successor as director of Herning Museum, Hans Peter

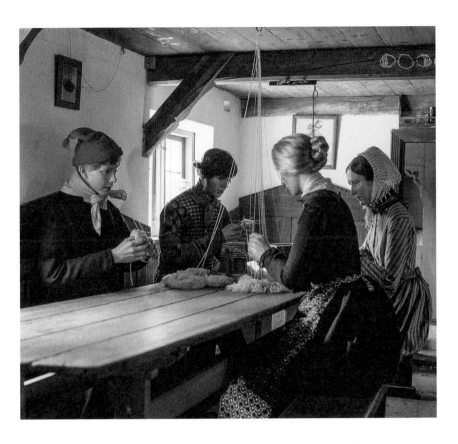

Hansen, described the founder as a deliberate collector of everything he found interesting, and:

"at least as pleased with wheat kernels, which are said to originate from the Egyptian pyramids, or with a knot of flint shaped remarkably like a mitten as he was with actual prehistoric finds."

Herning Museum soon began to focus on the particular history of life on the mid-Jutland heath. Its by-laws stated it was mainly to collect "things that give information about folk life in Central and West Jutland," one important task being to re-create a local peasant's home, complete with a *bindstouw* or 'knitting room' – a gathering where everyone would

knit woollen socks and garments and share stories and local gossip. This established its identity as a folk museum, even though, years later, Herning Museum would also become the first museum in what was then Ringkjøbing County to work professionally with archaeology.

Most local folk museums were housed in older buildings, but Herning Museum already moved into a new, purpose-built structure in 1909 – perhaps because there were no older buildings around. Beginning in 1904, a small open-air section was constructed, which still holds the *bindstouw*, an element which, more than any other, defined the identity of the town that became a Danish powerhouse in the textile and clothing industry.

Hans Peter Hansen was asked to head the museum in 1915, a position he accepted although it would not make him a living. In his first 25 years as director, Hansen got an annual salary of just 1,000 kroner, and he had to keep working as a conservator on the side while changing Herning Museum into a systematic, professional organisation. The collections were registered, the objects numbered, the museum's focus tuned ever more to the history of the Central Jutland heath. Working with the well-known Danish author and poet Jeppe Aakjær (1866–1930), Hansen gathered a large collection relating to another beloved poet, the much earlier Steen Steensen Blicher (1782–1848), famous for singing the praises of the heath. Hansen also oversaw the building of a dedicated knitwear museum portraying the region's history, from heath-tillers and sock-knitters to modern textile factories. In 1955 the museum had about 10,000 visitors – impressive, and on a par with the local museum in what had become Denmark's second-largest city, Aarhus.

Hans Peter Hansen was aware that a museum is

not just about *things*, but also, importantly, about *people* and their histories and stories. He acquired a camera as early as 1902 and used it when visiting old locals, coaxing them to share their stories. In the 1930s he began to film old work processes. When Hansen retired from museum life he left behind a body of work that is an exceptional, pioneering contribution to Central Jutland's history and ethnology: records, notes, and pieces about knackers, impostors, wanderers, wise women, healers and shepherds on the heath; books about cleanliness in the old days, and about rural dialects, folk medicine and conjuring. In 1959 his efforts were recognised when he received an honorary doctorate from Aarhus University.

Herning Museum grew quite influential across Ringkjøbing County, employing an academic head and receiving a national grant. In 1934 it was ranked as a central museum and received the annual 'large grant' of 2,600 kroner. In 1968, Herning Museum was designated a regional museum and given an advisory role.

Pick a theme

As we saw with the Danish folk museum, and with the applied-arts museum and the beginnings of Den Gamle By, themed museums with a national scope were foreign to the concept of Danish cultural museums. Basically, there was to be one central museum in Copenhagen, seconded by local museums across the country. Also, everything of national importance went to the central, state-owned museum, and local museums worked only with local history. This concept did not reflect reality, however, especially in the history of recent centuries.

New themed museums began to emerge and often had national reach. They grew out of gov-

ernment bodies whose history-keen employees often acted as custodians, and also grew out of professions, special-interest groups and individual crusaders.

Public institutions gave rise to museums large and small on themes such as customs fees (in 1912) and post and telegraphy (in 1913), initially all in Copenhagen. The Danish armoury museum was founded in 1928 as an independent institution under the Ministry of War. Its mission was to preserve, display and teach about the unique collection of weapons and military equipment accumulated over the centuries in Copenhagen, in the old armoury of Christian IV (1577–1648). Later, the marine museum grew out of the Danish Navy's own collections. In rail travel, enthusiasts at the Danish Railways had long been collecting, but not until 1975 did an actual railway museum open to the public, in central Odense.

Some specialty museums grew out of professional or trade circles, while others were founded on personal interests or convictions. In 1908, writer Hans Christian Andersen's house opened in his home town of Odense, and back in Copenhagen the technical museum was founded in 1911. Based partly on older collections from the great 1888 industrial fair in Copenhagen, the technical museum was long housed at the polytechnical college. Other museums from the same period arose at Kronborg Castle in Elsinore (trade and marine history, 1915), at Christiansborg Palace in Copenhagen (theatre, 1922), at Gammel Estrup manor on Djursland (stately homes, 1930) and in Hørsholm (hunting and forestry, 1942). Across the country, ideas and plans were brewing, many appearing in the latter half of the 1900s.

The number of open-air museums grew as well. As noted, Bernhard Olsen's museum in Lyngby

opened in 1901, and the embryonic 'old town' that grew into Den Gamle By was born in connection with the 1909 National Exhibition in Aarhus. The Hjerl Hede open-air museum was founded in 1930, and 1946 brought the Funen Village. Examples of the many small-scale open-air reconstructions are Glud Museum and exhibits flanking the museums in Herning, Haderslev and Maribo.

A trait shared by all these themed museums and open-air museums was that, in time and in themes, they were much closer to contemporary audiences than the prehistory museums were. Also, they were popular. So popular that often they reached whole new groups of museum-goers. We have no comprehensive lists of visitor numbers, but we know that in the mid-1900s these museums were quite busy. Estimated numbers for Denmark, a country of some 4.3 million souls in 1950, were: Frederiksborg Castle (200,000), the open-air museum in Lyngby (110,000), Hjerl Hede (100,000), Rosenborg Castle (100,000), Hans Christian Andersen's house in Odense (80,000), Den Gamle By (80,000), the Maritime Museum in Elsinore (70,000) and the Funen Village (65,000), plus the two town-castle museums that qualify as national attractions: Koldinghus (57,000) and Sønderborg Castle (48,000). In comparison, the National Museum in Copenhagen was receiving an estimated 200,000 guests each year.

Living history at Hjerl Hede

In 1930, the Danish businessman and politician H.P. Hjerl-Hansen (1870–1946) founded an open-air museum on a large heath in western Jutland, near the Limfjord. Rural buildings from across Jutland were moved to the new 'Hjerl heath' museum, whose signature is bringing to life old crafts and daily practices from the 1800s – as well as a Mesolithic

settlement where residents go about their everyday stone-age lives.

With its brand of living history, first tested in 1932, Hjerl Hede set new standards for how a museum could communicate with visitors. From 1955 onwards, a recurring summer highlight consisted in the museum's populating its 1870 village and its stone-age settlement with live-in enactors: a "volunteer-based, popular course of hands-on learning," as one enthusiastic journalist wrote. The visitors kept coming, more than any museum had ever seen. And the Hjerl Hede museum had done its homework, too, aided by the National Museum. As put by the chairman of the board, Finn Hjerl-Hansen (1910–1987): "This was *not* going to be a circus." Still, many experts were sceptical. Here, again, was the

gulf between some museum directors intent on preserving and displaying objects, whereas others wished to narrate and reach beyond the usual museum audience.

There were two outliers in the Danish open-air museum community: the Danish Open-Air Museum in Lyngby, and Den Gamle By in Aarhus. Both were national in scope. Both had distinct profiles in the international museum world: the former for rural buildings and culture, and the latter for merchant-town buildings and culture. However, while the museum in Lyngby was and remains a sub-section of the National Museum in Copenhagen, the open-air museum in Aarhus was and remains an independent institution that makes its own decisions, with its own board and a significant income of its own.

Urban history at Den Gamle By

Once the financial model for the 'old town' museum was in place, in 1916, it was time to set new goals. The Mayor's House still had its incomparable cavalcade of style interiors from the Renaissance up to "the time of our parents and grandparents", as founder Peter Holm put it.

Holm's plan was to add small timber-framed buildings that would become a "trades and crafts museum". The existing structures and suitable additions would contain the workshops he had already acquired – goldsmith, cobbler, needlemaker, candlemaker and ropemaker.

The great leap forward for Den Gamle By came in 1923 when the large Klingenberg complex in central Aalborg was condemned. The half-timbered buildings had actually been listed in 1918 as a class-A Danish heritage site, so the National Museum and the Ministry of Education bent over backwards

to find a solution. Alas, the old complex had to go. Then someone got a bright idea: Why not contact Peter Holm, that eccentric down in Aarhus who moved old merchant-town houses to his museum plot? A bright idea indeed, for Holm and his support network succeeded in saving the complex's eight individual buildings, moving them to Aarhus and reopening them as the Aalborg Houses in 1926. Knowing how much work it takes, even today, to move a single building, one can only be astounded at this achievement. The old town's new complex took the museum well beyond local boundaries, and after the rescue operation the museum's object clause was redefined to include, in theory, the citizens, crafts and trades of all Danish merchant towns. At the same time, the museum's name was altered to reflect its mission as "the old merchant-town museum" – with the last part its name retained today as Den Gamle By, 'the old town'.

At this point the mood had changed, in Holm's favour. His opponent and oppressor, Consul Ollendorff, had died in 1918, and in 1922 the historian and librarian Ejler Haugsted (1875–1959) became de facto head of Aarhus Museum. In 1924, Aarhus Museum sent an official request to Den Gamle By, proposing that its medieval and modern-history objects might be displayed in the Aalborg Houses, once the complex had been rebuilt, of course. A nice touch, recalling that this exact collection had become Holm's responsibility when he joined the museum's board in 1907. Aarhus Museum transferred the objects for the opening of the Aalborg Houses in 1926, initially retaining ownership but transferring that, too, to Den Gamle By in 1951.

Writing in 1927, Peter Holm described how

"more than fifty thousand visitors each year quietly

and considerately walk about in the old rooms. For anyone who wishes to conduct studies, there is still access; for students from technical and applied-art schools, usually access is free. And more than a few times the wall decorations, the shapes of the furniture and the varying styles of the metalwork have been used as models around the country."

From the late 1920s, and especially in the 1930s, Peter Holm added buildings from across Denmark. In 1931, the historian Helge Søgaard (1907–1990) joined Den Gamle By as a curator. In 1940, Søgaard was the first person to earn a doctoral degree at Aarhus University after defending a dissertation on the craft guilds of Aarhus, and he later became the museum's director.

On 18 May 1934, Den Gamle By celebrated its 25th jubilee (and its founder) with a Scandinavian symposium that gathered colleagues from Denmark and abroad. At this stage, Holm said, the museum had come so far

"that one can now see the idea behind it: to create an image of the old Danish town with its houses, larger and smaller, richer and poorer, and if one steps into the houses, one can see they have contents. Their parlours and rooms speak out loud of the people who lived in the old merchant towns."

The attendees at the symposium included Gösta Selling (1900–1996), who would later become Sweden's national antiquarian, and he brought special greetings from Skansen and Nordiska Museet, the sister museums in Stockholm. Selling was the main force behind the urban quarter built at Skansen, with inspiration from Den Gamle By. In fact, Holm and Selling were quite close and had visited each

other's museums several times. The day before the symposium, Selling published a piece in a major Stockholm newspaper praising "a Skansen in Denmark's second-largest city" with their museum partnership as a source of inspiration. Selling spoke of how Holm's ambition "of calling the Danish town to life" was now "largely carried through, just a quarter of a century later."

Peter Holm wanted his museum to enlighten, intrigue and delight people. That is why the entire environments and stories were important. It must have brought Holm great professional satisfaction to see that history as an academic and scientific discipline was ousting the rigid focus on sources and objective facts – making room for the return of story-telling. No longer would the authentic, individual object or the one crucial passage in a source be alone at the historical core, with all else seen as uninteresting. Academic historians and the open-air museums were increasingly working with a modern approach to the sources, where the answers are determined by the questions asked when exploring the sources. A leading Danish historian at the time, Erik Arup (1876–1951), called this 'taking poetic licence' with the sources. He saw it as the historian's task to apply a methodology to extract or distil the credible fact from the sources. In this there was nothing new. The new thing was that Arup said historians were obliged to "take poetic licence with the facts" they had found. And then, naturally – he wagged his professorial, source-critical finger – it was one's scholarly duty to do so based on "them all, not against them and not beyond them."

Interestingly, the approach the open-air museums took to educating and communicating was very progressive. From the outset their model was

remarkably well aligned with today's prevailing methods and principles.

In 1945, Peter Holm retired as director of Den Gamle By, and he became an honorary doctor at Aarhus University the following year. Holm died on 1 February 1950 at the age of 77. Although few would have thought of this at the time, what he had created was the world's first open-air museum for urban culture and history.

As posterity showed, his results also directly inspired many other, similar efforts, most notably the urban quarter of Skansen in Stockholm, the Finnish craftsman's museum Klosterbacken in Turku, Old Bergen in Norway and Old Linköping in Sweden.

In 1945, Helge Søgaard took over at Den Gamle By, and his directorship opened another chapter in the museum town's history. Once again the scientific work and individual museum objects were brought to the fore, as the efforts to broadly reach and educate guests slipped into the background. But despite concentrating more on its own historical pursuits, Den Gamle By remained one of Denmark's favourite international tourist attractions.

Prehistory in Aarhus

After transferring its medieval and modern-history collections to Den Gamle By, the venerable Aarhus Museum came to focus much more on prehistory, its remaining collections still housed in the now cramped original museum building from 1877. The problem of space was not solved until 1970 when Aarhus Museum moved to Moesgaard Manor, south of the city, and changed its name to the Prehistoric Museum.

Like several other early museums outside Copenhagen, Aarhus Museum was not merely a

local museum with local collections. It was a proud board that noted, in 1939, that the previous year Professor Johan Plesner (1896–1938) had reviewed the collections with a group of senior students and declared that "the museum is the main collection of prehistoric artefacts in Jutland, and is Aarhus University's prehistoric study collection."

The museum's relations with Aarhus University (founded in 1928) were strengthened in 1949 when the prominent archaeologist P.V. Glob was made a professor there in prehistoric archaeology. His chair was linked to the other half of his position: director of Aarhus Museum. Under his leadership the museum expanded its special field – prehistoric archaeology – with ethnography. Its staff grew, and in 1950 a full-time conservator and curator were taken on, in addition to the administrative staff. In 1952 the excavation of the surprisingly well-preserved bog find known as the Grauballe Man (c. 300 BC) suddenly gave the museum new appeal. The dramatic story of 'the Bog Man' and the exhibition later built around him not only made the front pages. It made the museum a popular attraction.

From 1953 on, the museum's position was consolidated by its involvement in expeditions to Bahrain and other countries on the Persian Gulf. Extensive digs and ethnographic collection work gave the museum a very distinct profile for a whole generation of students and curators.

Two very different museums had grown out of their parent institution, Aarhus Museum. Although both developed into highly specialised museums, even today they retain their local links and engagement in the history of their native city, Aarhus.

"Meet the family" is the motto at the new Moesgaard Museum, which opened in the forested hills south of Aarhus in 2014. The museum's central staircase is referred to as the "evolution stairway" because visitors can get a close-up impression of our ancestors through life-sized and anatomically correct reconstructions.
|| Moesgaard Museum

Museums about people

Out with the old

In a talk he gave in 1971, the historian and political-science professor Hans P. Clausen (1928–1998) boldly claimed it was not until 1960 that social modernisation in Denmark had progressed enough to move beyond the mindset of the 1800s. Certainly, this was generally true of the country's museums. Not until the 1960s and 1970s did they begin to experiment with new methods and techniques that broke with tradition. And not until the new millennium did a visitor-centric approach gain such a following as to be the prevailing trend among Danish museums of culture.

Several shifts occurred in Denmark in or around 1958. An economic upswing replaced post-war lethargy, bringing growth and better welfare services. As a Social Democratic election poster read a few years later: "Make the good times better." Also in 1958, the *Folketing* passed the first law ever to govern local museums of cultural history, heralding half a century of law-making and huge developments for the country's museums. Decentralisation also made the agenda, with a Danish law on regional development. And 1958 was also the year the art enthusiast and businessman Knud W. Jensen (1916–2000) opened a new modern-art museum he called 'Louisiana' – located north of Copenhagen – setting new standards for the museum as experi-

ence, event and attraction. Jensen's grand vision, complete with café and shop, was not well received by all, but the public was thrilled and 'the Louisiana model' gradually gained ground in cultural-history museums as well.

The effects of 'the new' were not immediately visible, however. In fact, a cultural-policy report, commissioned by the centre-right government and published in 1969, gave Danish museums – not least cultural museums – quite a thrashing. It concluded that the youth uprising had left the museums untouched, the reason being that the rebellious young generation regarded museums as utterly toothless "repositories for the remains of former societies", and thus not "worth wasting any energy on".

The verbal blows in the report rained down on the National Museum and local museums alike; outdated museums where visitor-relevance seemed to be a foreign concept. It was high time to comprehend, the report continued, that museums now "only played a relatively subordinate role among the many ways in which the population could spend their free time." It also gave an almost caricatured description of "the classical museum display case" with rows of objects arranged on shelves "so awkwardly one must bend at the knees to see them", and with more or less illegible labels which "in themselves are a relic of the past". The conclusion: "many museums today are, themselves, ready to be retired to a museum."

The report stressed that museums must understand that "leisure habits have been radically changed", accepting, like libraries, theatres, radio and television, that they carried the "very important task of entertaining". Rather than creating a "distance between the relics and the visitors", many museums would do well to learn from open-air

museums and others that used the characteristic "interior principle". A specific slap to the National Museum read that "the current mode of exhibiting is wrong vis-à-vis the audience." The large number of objects on display

"put a strain on visitors, who lose their way, become less receptive, and in many cases find it a slow, tedious trek through the rooms."

Museums ought to be inviting and accessible instead, using exhibiting principles where "relatively few characteristic objects are displayed in the rooms." Also, the report recommended that museums be much more visitor-oriented, with

"guidance in the form of informative, easily readable texts, posters, illustrations and photographic material, which together give a clear and relatively easily understandable picture of the historical progression."

Museums were also recommended to support exhibited materials with films and slide shows. On the whole, they ought to strive to become "living institutions" that worked together with various cultural and educational societies. If they did not change but stayed on the beaten track, "one should not foresee a future where they have any general beneficial function for society."

In retrospect, the past fifty years have definitely brought great change to museums in Denmark. The commissioned report hardly achieved this on its own, yet it was important because it set a course for the future. Since 1969, the Danish museum community's ability to reach the population has doubled several times over, with annual visitor numbers

rising from just under 4 million in the late 1960s (in a population of then 4.7 m) to more than 15 million in 2018 (population 5.8 m) – most of whom visit cultural museums. Narrative modes have surged, and today very few museums do *not* do their utmost to welcome and engage their guests.

Way out in Brede

The National Museum was first off the mark with innovation, but the new trend did not come to the hallowed halls of the Prince's Palace. 'The new' was relegated to a place called Brede, out in the country about 15 km north of the capital. Perhaps the museum had received a firm but friendly word of advice. Or perhaps the initiative came from the unorthodox P.V. Glob, who had moved from Aarhus to Copenhagen in 1960 and now served as

Denmark's national antiquarian and director of the National Museum.

The Danish Folk Museum, Den Gamle By and Hjerl Hede had broken new ground many years earlier. Now Sophus Müller's own museum was breaking its master's mould. The result was a series of visitor-centric experiments each summer, from 1966 to 1988, testing new kinds of museum narration in an old textile-factory building and surroundings. The museum experiments at Brede ended over thirty years ago, but many still recall 'the Brede Exhibitions' as a sort of cultural-history counterpart to what the Louisiana museum in Humlebæk was doing with art. "There was no rigid etiquette or elevated distancing," as the communication researcher Carsten Tage Nielsen (b. 1962) wrote in his in-depth study of the Brede Exhibitions. A visit to Brede was fascinating, surprising, educational, fun – a treat for the whole family. The former factory buildings did not intimidate anyone, and the nearby stream and meadows were an attractive recreational backdrop.

The Brede Exhibitions, numbering 20 in all, dealt with various themes, one per exhibition. Some focused on a specific historical period such as Eric the Red and the early medieval period in Greenland (1967). Others took a longer view, for instance exploring the spread of Buddhism in Asia over 2,500 years (1970). Some exhibitions cut across time and space, treating topics such as clothing (1971) and nutrition (1976/77), while others celebrated important events in Danish history, like the bicentennial of the law abolishing villeinage. Other memorable themes were sports (1972), China (1975), the dangers of living (1978/79) and the roofs over our heads (1987).

The concept worked with a wide variety of displays and communication methods, from reconstructions and panoramas to live re-enactments

and creative audio-visual work. The exhibitions in Brede had fewer objects and less text than most other exhibitions, but more teaching and activities, as well as areas for refreshments and relaxation.

The 1970 exhibition on "the ways of the Buddha" exemplifies the success at Brede, attracting a total of 183,230 visitors. Tickets were 2 kroner for adults (then roughly the price of two chocolate bars) and just 50 øre for children, students, soldiers and senior citizens. Unlike the Brede Exhibitions, a visit to the National Museum at the Prince's Palace was free. In 1970, the large museum in the capital had 226,000 visitors – though not in five months (the season at Brede) but over an entire year.

In 1988 when the last Brede exhibition closed, so did the National Museum's experiments. It was time to concentrate on the extensive rebuilding and expansion of the Prince's Palace complex, a project initiated by Olaf Olsen (1928–2015), P.V. Glob's successor in 1981 as museum director and national antiquarian.

A rejuvenated National Museum in the Prince's Palace was ready to welcome the public in 1992, complete with a modern foyer, restaurant and museum shop. It reopened with a successful special exhibition on Vikings and Christianity, displayed in the modern special-purpose rooms that were probably the project's largest benefit. This exhibition suite has since housed many temporary exhibitions, all beautifully designed and built on solid, in-depth research. Still, when the parent museum dismantled its quirky offshoot in Brede, it had not brought the unexpected, amusing, trailblazing touches back to central Copenhagen.

The new permanent exhibitions there, done after the rebuild, saw story-telling replaced by thousands of objects on show. The conservative camp

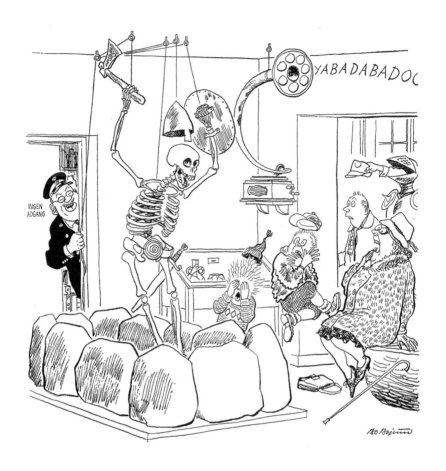

had seemingly risen to power again. In 2008 the new prehistoric exhibition earned a telling headline in a major Copenhagen daily: "Large prehistoric show extremely old-fashioned." Sophus Müller would have felt more at home at the Prince's Palace in 2008 than in Brede fifty years earlier.

In 2018, for financial reasons, the National Museum stopped doing large temporary exhibitions at the Prince's Palace. Alternatively, its new director from 2017, the anthropologist Rane Willerslev (b. 1971), installed a 'boredom button' meant to shake off the cobwebs and bring a new vitality to

the museum. Typically, children press the boredom button and trigger a feature that complements and invigorates the many lifeless display cases.

The Danish museum model

The 1958 Danish Museum Act on cultural-history museums was followed by legislation in 1976, 1984, 1989, 2001 and 2012 that gradually came to cover all museums receiving state funding. With today's museum act, which covers virtually all major museums in the country, the museum landscape has become more decentral, democratic and professional. The carrot was state funding, granted in proportion to the local funding a given museum received. The result was formidable growth in the museums' budgets and skills, boosted, obviously, by the overall financial upswing and the emergence and development of the Danish welfare society.

New law required all museum directors to have a relevant academic degree. In the cultural museums, directors and section heads were typically archaeologists, historians, ethnologists or ethnographers, while a staff of conservators looked after the artefacts and material heritage. Large museums had their own conservation departments, while others set up regional conservation centres. From the 1970s onwards it became common to expand the staff with museum educators or 'interpreters' who could make the collections and narratives relevant and accessible to the public.

The 1984 act obliged all museums to work across the entire spectrum of classical museum activities, later called 'the five pillars': collection, registration, preservation, research and education. Until then, the National Museum had done virtually all the research, although gradually several large national themed museums also contributed. However, the

1984 act stipulated that all museums – whether state-owned or state-recognised, regional, theme-based or local – were to work with all five pillars. As a result, the National Museum lost its 'right of the firstborn' to claim a monopoly on research.

The number of state-recognised cultural museums eligible for funding was 38 in 1958, growing to 72 in 1970 with more on the way. With the 1976 act, themed museums, including Den Gamle By, went from being an item on the parliamentary Finance Act to being covered by museum legislation. A couple of legislative cycles resulted in a new category: "section-16 museums", which the 2001 act described as "state-recognised museums [...] of special significance, including their handling of a specialised museum field." This firmly established the Danish museum model, which has three categories: the National Museum as the main institution, museums with nationwide special themes or profiles, and local museums.

Besides working with the five pillars, local museums – an extremely broad category – all carry out an important task: public supervision of any invasive, large or lasting changes to landscapes and building environments. Projects requiring supervision may be public or private, and a local museum may intervene by excavating to secure archaeological traces, or by officially objecting against major change of a built-up area, the former intervention being used much more often than the latter.

Danish law is still largely in line with the basic idea from 1807, which established the Prehistory Commission and later became embedded in the Norse Museum, the National Museum and the prioritisation of museum funding in general – meaning prehistory took precedence over later periods. That is why, to this day, archaeology remains the uncon-

tested leader among museum disciplines in Denmark, and also why prehistory, seen collectively, carries far more weight in museum budgets than modern-history work on recent centuries.

Back and forth

In keeping with the development of ever-stronger museums outside the capital, gradually the control exerted by the National Museum for nearly a century diminished. In a nutshell, this long and complex course of events meant that the supervisory role was moved to other bodies, transferring in 1958 to a local-museum supervisory authority, and in 1976–2001 to a national collegiate museum board. Ultimately, however, supervision did revert to a national body when the Cultural Heritage Agency was set up in 2001 – although it only supervised state-recognised, mainly independent museums. The museums directly owned by the state – most notably the National Museum – were, and are, supervised directly by the Ministry of Culture. This is why the whole idea of ending up with one joint, cohesive museum body covering all of Denmark never really came to pass.

For some time, decentralisation was implemented by letting regional bodies handle various tasks, which were later returned to the state agency. The 1958 Museum Act made large local museums with qualified staff into 'regional museums' that could advise and instruct other museums in their region. These were replaced in the 1976 act by 'county museum councils', which did the same for all museums (state-owned, state-recognised and private) in their county and also assigned certain museums special roles and tasks. In changing configurations before and after the dissolution of Denmark's counties (as of 2007), various local and

In 2017, the Varde museums opened a brand-new site where history and architecture revolve around the Tirpitz fortification, part of the Atlantic Wall along the German army's WWII defence perimeter. The museum's narratives, all about Jutland's West Coast, employ evocative scenography, notably in the permanent exhibition West Coast Stories, which suddenly unfolds into an epic 360-degree film. The building was designed by BIG architects and the museum's exhibition-design partner was the Dutch firm Tinker Imagineers.
‖ Mike Bink/Tirpitz

state bodies supervised the museums. Ultimately the task returned to the national level under the Cultural Heritage Agency, which in 2012 assumed broader responsibilities, beyond heritage, and was later renamed the Agency for Culture and Palaces.

But law is one thing; networks another. Importantly, the Danish tendency to decentralise has always been underlaid by a distributive constant: collaborative networks among museums and colleagues. The earliest association, bringing Danish cultural-history museums together, was founded in 1929. Since the 1970s many networks have increasingly been discussing how museums can better reach their audiences. Today, the Association of Danish Museums, founded in 2005, brings together all sorts of museums to discuss everything from specialised academic fields to museum policy.

Specialties and niches

The 1960s heralded a new wave of specialty museums, many of which rapidly gained a large following. The list of themes and locations is long and varied, as seen in these examples: fisheries and sailing (in Esbjerg, 1962), the Limfjord (in Løgstør, 1965), Viking ships (in Roskilde, 1969), an expanded technical museum (in Elsinore, 1969), an expanded agricultural museum (at Gammel Estrup manor, 1972), railroads and trains (in Odense, 1975), industry and manufacturing (in Horsens, 1977), graphic production (in Odense, 1983), workers and the labour movement (in Copenhagen, 1983), women (in Aarhus, 1984), electricity (at Tange, near Viborg, 1984), stranded warships (in Thorsminde on the West Coast, 1992), posters (in Aarhus 1993) and the Jewish community in Denmark (2004). Also, the post and telegraphy collections have moved twice (in Copenhagen, 2006 and 2015), and as of 2019 an

ongoing project called Enigma is developing a whole new communications-museum concept.

Specialty museums tend to have more public appeal than do local museums with their wider scope. No doubt that is why more and more local museums are finding a special niche of their own. Herning Museum still focuses on Central Jutland's textile industry, and Struer Museum tells the story of the town's audio-video giant Bang & Olufsen. The museum in Vordingborg has set up the Danish Castle Centre, and Varde Museum is behind the immersive-exhibition success Tirpitz about the history of Jutland's West Coast – and also working towards a refugee museum at Oksbøl, which after World War II was Denmark's largest camp for German refugees. The town of Ribe opened a museum in 2019 for a

famous native son: the Danish–American photographer Jacob A. Riis (1849–1914), and Ribe Museum is also working towards another museum based on a high-profile Danish witchcraft trial in 1641 against a woman named Maren Splids, historically portraying the persecution of 'witches' in Denmark.

Beneath the canopy of recognised, influential museums is a motley undergrowth of museum-like, themed initiatives, many of which call themselves museums ... of bicycles, circuses, suburbs, Elvis, men, contemporary living, tractors and Volkswagens, to name but a few. Many grow out of a personal passion and will hardly survive their founders, whereas others may, in the fullness of time, grow to find a place in the lush canopy of state-recognised museums.

People meeting people

Now let us bring our whirlwind journey through the history of Danish museums back to where we began. Back to Aarhus, pre-1909, where a conflict was raging at the town's museum about its mission, and about Peter Holm's unconventional ideas. In the 1900s, Aarhus Museum developed into two separate museums – one for merchant-town history, and one for prehistory and ethnography – and in the new millennium, both Den Gamle By and Moesgaard Museum have evolved into two of Denmark's most popular museum attractions.

In 1970, the prehistoric museum had left the old Aarhus Museum building and moved some ten kilometres south, taking over a large manor-house complex known as Moesgaard, located in the forest near the bay. The museum came to work in close, formalised partnerships with archaeologists and anthropologists at Aarhus University, where the prehistoric museum's director held a parallel pro-

fessorship all the way up to 1980. The great wings that had once housed stables and stalls became home to the Prehistoric Museum's permanent exhibitions of Stone Age, Bronze Age and Iron Age artefacts and history. A suite of rooms was also reserved for temporary exhibitions not unlike those the National Museum organised in Brede. In 1977, after several years of planning and preparing, the first Viking Moot was held on the seaside meadows near Moesgaard. This has since been a major annual event for Aarhusians and Viking enthusiasts from around the globe.

In 1997 the museum changed its name to Moesgaard Museum, and after years of planning and fund-raising the museum's director, the archaeologist Jan Skamby Madsen (b. 1947) was able to break ground in 2011. This started a process in which, over the next three years, a brand-new museum building almost seemed to grow out of the hillside overlooking Aarhus Bay. With its opening in 2014, the new museum broke once and for all with the display traditions which, since the time of Sophus Müller, had been straight-jacketing the principles and people working at archaeological museums.

"Meet the family" is the welcoming message to visitors arriving in the large, spacious foyer that also contains a restaurant and shop. To reach the exhibitions, guests proceed down the huge stairway illustrating evolution through seven life-sized and anatomically correct reconstructions of distant ancestors of *Homo sapiens*. Right from the start, humankind, not artefacts, are the focus of attention, an angle that is consistent throughout the exhibitions on the Stone Age, Bronze Age, Iron Age, Viking Age and the Middle Ages. The ethnographic exhibitions also revolve around life and,

not surprisingly, death with its diverse rituals and customs.

Moesgaard Museum, a modern-day mecca of prehistory and ethnography, offers exceptional facilities for temporary exhibitions. It has already hosted hugely successful themes such as the early Chinese emperors, gladiators, Genghis Khan, and Pompei and Herculaneum, and its annual visitor numbers range from 300,000 to 500,000.

With these new exhibitions, Moesgaard is the only archaeological museum in Denmark (to date) to embark on the new path of exhibiting and story-telling. In recent years the trend has also given rise to popular narrative exhibitions at the new Maritime Museum of Denmark in Elsinore (opened in 2013), Tirpitz near Varde (opened in 2017) and Den Gamle By's underground time-travel odyssey, Aarhus Stories (opened in 2017).

Back in the early 1960s, however, Den Gamle By had been curling in on itself for more than two decades. Then, when Hans Lassen (1911–1987) took over as director after Helge Søgaard in 1964, the old merchant-town museum once again started putting people on the agenda. Lassen began a program of temporary exhibitions, especially showcasing artefacts from the museum's large collections of applied design. He also sought to popularise the museum as a venue by organising large open markets during the annual Aarhus Festival Week in September.

These aspects became even more prominent under the museum's next head, Erik Kjersgaard (1931–1995), who was director from 1982 to 1995. Kjersgaard realised the importance of the museum making its own money, and to achieve this he not only expanded the number and scope of markets and events. He also approached the business community – as one of the first museums in Denmark

– seeking sponsors to help maintain the historic buildings. The ticketing and pricing policy was also changed, and since then Den Gamle By's own earnings have doubled many times over, today constituting the primary source of income for the museum's work and activities.

From the mid-1990s the immersive experience once again took precedence. Under the slogan "Back to Peter Holm", the museum's staff looked elsewhere for inspiration. Den Gamle By began developing a concept in 1997 to tell the history of Christmas throughout the museum's 400-year time span. Since 2001 the Christmas season has been extra lively, with decorated homes and shops, outdoor sales stalls, historical Christmas food, music, theatre, guided tours in the dark, and living-history characters. In the last six weeks of each year, Den Gamle By welcomes some 150,000 guests.

"Come taste, smell and try out history." From the start, this was the motto for the living-museum concept at Den Gamle By, where guests meet people from the past in meticulously recreated historical settings. The inspiration came from Hjerl Hede and a number of Dutch and Swedish open-air museums. "Fun fair and hot air," some cried, but museumgoers love re-enactment. As ever more museums focus on people, living-history techniques are increasingly becoming accepted and employed.

Parallel to these activities, research was boosted. Inspired by Moesgaard Museum and the Fisheries and Maritime Museum in Esbjerg, in 2001 Den Gamle By formally partnered with Aarhus University to form a new joint research centre: the Danish Centre for Urban History.

A new old town
In 2003, Den Gamle By went public with the idea of

The 1974 neighbourhood at Den Gamle By has several homes where visitors can sit in the chairs and open the drawers and cupboards. During re-creation, the curators worked closely with each home's original occupants. In 1974 this flat was home to 12-year-old Per, who lived here with his divorced mother. Guests are welcome to share the sofa and watch highlights from the FIFA World Cup final on 7 July 1974, where – spoiler alert – West Germany beats the Netherlands 2–1. || Den Gamle By

a modern urban district, raising a wave of resistance. It was almost like a distant echo of the opposition against Peter Holm's original idea nearly a century before. But the museum realised that even its newest elements portrayed a time no one alive had experienced in person. Peter Holm, in his day, had deliberately constructed his cavalcade of interiors up to "the time of our parents and grandparents." And abroad, notably in Holland and Norway, sister museums had begun to open buildings and interiors from a time closer to our own, not on a large scale but with great success.

And so it was decided that Den Gamle By was to be more than just a functional, physical manifestation of a preindustrial merchant town. It would become a journey in time, from the old merchant town through 'the modern age' in the 1920s, and up to a time most of today's adult Danes recall. The year 1974 would be the snapshot point for re-creating Denmark in the 1960s and 1970s.

It was a radically new and wildly ambitious project. Still, no one at the museum had foreseen the instant thumbs-down from the national cultural-heritage agency. It was a resounding: "No". It was wrong to move buildings, and Den Gamle By's mission was not to build collections from the twentieth century. Consulting the past, as it were, Den Gamle By discussed the matter with its oldest member of staff, historian Erna Lorenzen (1909–2006). Having joined the museum in 1935 and worked closely with Peter Holm, she was well versed in his thinking and his views. After thinking at length about what her original director would have thought of the project, Erna Lorenzen concluded they were both wholeheartedly in favour.

A large charitable donation made the project a reality, and as the results gradually materialised,

opposition turned to enthusiasm. The project, largely completed as of 2020, comprises 14 multi-storey buildings relocated from various Danish towns and integrated into what, in 2022, will be a full city block. The theme of the three sides of this block based on 1974 is "daily life in the Danish welfare state", showing new developments in society and youth culture in the 1960s and 1970s. Eventually, the fourth side of the block will illustrate 2014.

This new area portrays life in Denmark through personal narratives from over thirty people, from a time many Danes remember well. In keeping with the open-air concept, visitors can walk right into the living rooms, bedrooms, kitchens and bathrooms of bygone days. This is not a history of

conflicts, kings and capitals cities. The focus here is on daily life, untold stories and forgotten places. Now, as before, narratives about ordinary lives are often richer and more touching than the great tides of national history.

Visitor numbers reflect the success, having grown from an annual 320,000 or so (around 2000) to more than 500,000 since 2015. A recent study of museum-goers done by the Danish cultural-heritage agency shows that the visitor profile at Den Gamle By quite closely mirrors the composition of Denmark's 5.8 m inhabitants.

In 2017 the history of Aarhus returned to Den Gamle By in earnest, several years after the larger museum took over the local-history work done by Aarhus city-history museum from 1992 to 2011. Part of the 'new old town' involved the opening in 2017 of a large, interactive underground exhibition – Aarhus Stories – where visitors, like time-travellers, can journey through the development of Aarhus, from its humblest beginnings as a Viking settlement on the bay, at the mouth of a stream, to a modern university city where students and tourists enjoy a rest at the busy cafés along the banks of the very same stream our predecessors plied in their shallow skiffs. But that is a story for another day – and another provincial museum called Moesgaard.

Museums today are increasingly defined by their architecture, few as much as the Maritime Museum of Denmark, designed by the Danish architect firm BIG and built into an old dry dock from the Elsinore shipyard. It recounts the maritime history of Denmark in an appealing, interactive environment created in close collaboration with the Dutch design firm Kossmann.dejong. || Luca Santiago Mora/ M/S Maritime Museum of Denmark

The future

Know thyself!

In Denmark we have long tended to regard museums as a service mainly run on public funds reserved for culture. This model is under pressure as the public sector becomes increasingly focused on its own institutions and other, more urgent tasks. Today's seasoned museum-goers are also more demanding, which calls for more distinct museum profiles, more intense exhibitions, innovation and better service.

The need to redefine the role and relevance of museums is indisputable, and the exercise will seek a model that enables museums to continue to play a role in the future. Certainly, in Denmark and elsewhere, museums cannot count on public funding to indefinitely maintain operating budgets that resemble those of the past 50–60 years. And ultimately, no one can even be absolutely sure we will want to have museums in the future.

Museums nowadays are very diverse, a trend that will probably continue, making the museum landscape even more varied. Bravo! But this means that each museum must find his own platform, based consistently on its intended target group.

Prominent museologists have offered salient points for those interested in charting potential courses for the museums of the future:

Today the attractions are "setting the tune to

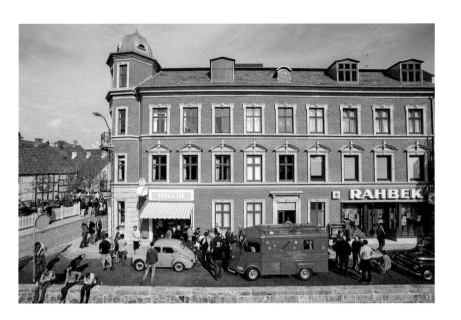

In the museum town of Den Gamle By, guests can literally become one with history – even their own history, in a modern townscape modelled on 1974. There are streets and shops, homes and hide-outs, workshops and 'watering holes' where locals would meet. The new 1974 neighbourhood once again reflects Peter Holm's principle of showing settings that resonate with contemporary visitors. || Den Gamle By

which we will all ultimately have to dance," as the Canadian museum director George F. MacDonald (b. 1938) put it back in 1987. In several analyses MacDonald has described the growing competition museums face from science centres, theme parks and other, more commercial attractions. His refreshing and proactive view is that museums must see this as a challenge, of course maintaining their professionalism and credibility but also putting an end to their elitist, often dusty image. MacDonald also believes that museums must use the same "weapons" as "the opponents": more business-like operations, professional marketing and – obviously – a visitor-centric approach with more verve and engagement.

Museums should once again be the home of the muses, as the late British museum director of Beamish open-air museum, Peter Lewis (1938–2016), suggested in 2004. He took his cue from the word 'museum', derived from the ancient Greek *museion*. The original Museion was regard-

ed as the home of the nine muses, all daughters of Mnemosyne, the goddess of memory and recollection. Lewis made a shrewd and highly polemical observation in his ongoing offensive against what he called "the museums-should-be-dull brigade": Curiously, only the muses of history and astronomy, Clio and Urania, are subsumed under the modern museum concept, whereas the other seven muses, who are related to the more creative aspects of human life, are left out. He argued that the excluded muses ought to be invited back to sit at the hearth of cultural-history museums, reintroducing poetic, artistic and dramatic aspects into the museum sphere. In this way Lewis also linked the museum concept with a humanist world view, rather than with the scientific approach that mainly sees museums as a bank of information where visitors come seeking knowledge.

Museums should change "from being *about* something to being *for* somebody," said a 1999 article by the American museologist Stephen E. Weil (1928–2005), who was writing on the constant state of change in American museums. A similar view was expressed by David Fleming (b. 1952), the director of the National Museums of Liverpool from 2001 to 2018. Speaking at a conference in 2013, Fleming offered his take on the primary role of museums: to serve their societies and local communities as more than mere custodians of objects; to show social responsibility and address today's important issues; to identify and tell stories that engage, touch and involve ordinary museum-goers.

Museums should be "about me," Olav Aaraas (b. 1950), the director of Norsk Folkemuseum, pointed out in 2009 at an international conference on open-air museums. "What is it that interests museum visitors more than anything else?" Looking out over

the conference hall inquisitively, Aaraas answered a moment later: "Themselves." Putting this into perspective, he added: "All of us want to be reunited with our own lives, our own history. [...] History did not end 50 or 100 years ago. It rolls on, and we are part of it."

"Let us see it as an honour to be a museum for the people," the Swedish museum director Sten Rentzhog (b. 1937) once said. The occasion was a talk he gave in 1987 when taking over as director at Nordiska Museet in Stockholm.

"We ought to be a museum people can identify with; a museum where no one has to feel they are worth less than others; a museum that is owned by everyone [...]. Our primary target group does not consist of the culturally active. It consists of those who love charter trips to Mallorca, TV-watchers, windsurfers – all the ordinary people who would never dream of visiting a museum."

Interestingly, Sten Rentzhog is fully in line with Artur Hazelius, his earliest predecessor and founder of the two shockingly innovative Stockholm museums of the late 1800s. As a motto for his museum work, Hazelius chose the Swedish version of the aphorism "Know thyself", taken from a famous inscription on the wall of the Apollo Temple at Delphi.

"Know thyself!" His point is clear. Neither ages past nor artefacts present are the higher purpose of museums. What matters is serving the people who visit museums. Today and tomorrow.

Further reading

Bloch Ravn, Thomas: *Den Gamle By. A Window into the Past.* **Gyldendal 2002**
A richly illustrated monograph on the origins and evolution of Den Gamle By.

Jensen, Inger & Henrik Zipsane (eds): *On the Future of Open Air Museums.* **Östersund. Sweden 2008**
Anthology based on a conference held at Skansen in Stockholm, including a presentation of Sten Rentzhog's book.

Rentzhog, Sten: *Open Air Museums. The History and Future of a Visionary Idea.* **Sweden 2007**
The most detailed and comprehensive review of the history and distinctive features of open-air museums around the world.

Williams-Davies, John: **"'Now Our History is Your History': The Challenge of Relevance for Open-Air Museums" in** *Folk Life. Journal of Ethnological Studies*, **vol. 47, United Kingdom 2009**
An overview of the history and distinctive features of open-air museums.

Zipsane, Henrik: *National museums in Denmark* **in Peter Aronsson & Gabrielle Algenius (eds): Building National Museums in Europe 1750–2010, Conference proceedings from EuNaMus, Bologna 2011**
A review of the emergence and development of national museums in Europe.

Visit our website – **www.100danmarkshistorier.dk** – for the full bibliography and notes in Danish.